IMAGES
of America

EAST WINDSOR

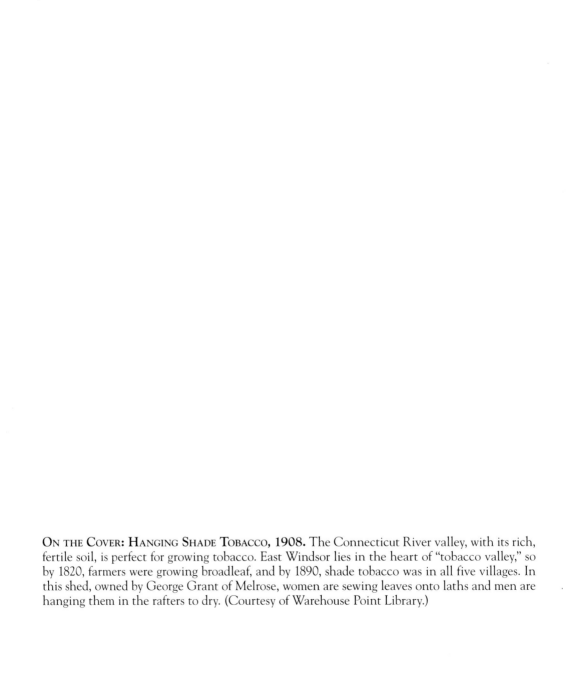

ON THE COVER: HANGING SHADE TOBACCO, 1908. The Connecticut River valley, with its rich, fertile soil, is perfect for growing tobacco. East Windsor lies in the heart of "tobacco valley," so by 1820, farmers were growing broadleaf, and by 1890, shade tobacco was in all five villages. In this shed, owned by George Grant of Melrose, women are sewing leaves onto laths and men are hanging them in the rafters to dry. (Courtesy of Warehouse Point Library.)

East Windsor 250th Calendar of Events - 2018
Subject to Change

New Year's Eve - Masquerade Ball (December 31, 2017)

January:
1st –First Day Hike

February:
17th - Winter Festival w/outdoor winter activities at Scout Hall

March:
21st - Victorian Lady Tea Party at EW Senior Center

April:
18th – "Parrish" film showing at Warehouse Point Library @ 6:30 PM
21st – "Parrish" film showing at Warehouse Point Library @ 2:00 PM

May:
5th - Vintage Baseball Exhibition Game at EWHS
19th - Town Meeting/Open Bicentennial Time Capsule

June:
2nd - CT Trails Day Hike
3rd – Broad Brook Opera House Open House
9th – House/Garden Tour
16th - Food Truck Fest and Reenactment at Scout Hall
30th-Cardboard Boat & Rubber Duck Races

July:
14th– Warehouse Point Fire Dept. Touch-A-Truck
15th - Sundae / Fun Day at The East Windsor Park & InfoShred Truck

August:
4th - East Windsor Day at CT Trolley Museum
11th - Historical Society's Ice Cream Social
24th – Dinner & Movie at Scout Hall

September:
Discount Tickets to Opera House for EW Residents
22nd - Community Day/Parade/Picnic/Fireworks

Visit www.EW250.com or find us on Facebook for up-to-date information.

IMAGES
of America

EAST WINDSOR

Ceil Donahue and Jessica Bottomley
with the East Windsor Historical Society

*Enjoy reading
about our town!*

ARCADIA
PUBLISHING

Published by Arcadia Publishing
Charleston, South Carolina

Printed in the United States of America

Library of Congress Control Number: 2016956256

For all general information, please contact Arcadia Publishing:
Telephone 843-853-2070
Fax 843-853-0044
E-mail sales@arcadiapublishing.com
For customer service and orders:
Toll-Free 1-888-313-2665

Visit us on the Internet at www.arcadiapublishing.com

*We dedicate this book to all amateur historians of East Windsor who
kept a photograph or wrote a paragraph to keep the town history alive.*

CONTENTS

ACKNOWLEDGMENTS

Incorporated in 1768, East Windsor celebrates its 250th anniversary in 2018. This book is only a small snippet of the true history of East Windsor. All the people and places that were so important to the development of the town could not be included, since so much has happened since the first settlers came in the 1600s. We decided to concentrate on the earliest history of the town and tell how each village developed and became one town, East Windsor. Choosing which photographs to place in the book was very difficult, and many photographs no longer exist. We in East Windsor can be very proud of our heritage, the villages that formed it, and the people who lived and worked in it.

We are truly grateful to and recognize our proofreaders Edward Donahue and Diane LaJoie. A special thank-you to Michael Salvatore for writing the introduction and reading the final manuscript. All their suggestions and critiques were invaluable. A shout-out to Michael Hunt, the historical society's current president, who always seemed to ferret out the one photograph that we could not locate.

The fire departments, the Warehouse Point Library, the Connecticut Trolley Museum, and the citizens of East Windsor were also eager to help by providing their photographs and sharing their stories about the town. It was a joy to talk to and meet with each of them. We thank all of them and appreciate their input. They are credited in the courtesy lines. Hopefully, you will enjoy reading this book as much as we enjoyed preparing it.

Jessica Bottomley provided her vast knowledge of the town's history gained through her experience as archivist for the historical society, and her computer expertise. Ceil Donahue, having experienced aiding and bringing to fruition Joseph Vozek's 1994 two-volume work *The Village of Broad Brook*, wrote the text.

Unless otherwise noted, all images appear courtesy of the East Windsor Historical Society.

INTRODUCTION

The land has long been East Windsor's main attraction. In the 1630s, white settlers were drawn by the rich soil and the even topography of the Connecticut River valley. Earlier, Native Americans found the streams and rivers suitable for their lifestyle. Several clans of the Podunk tribe lived on the land east of the great river. The Namericks occupied the Warehouse Point area, and the Skeantockes occupied the Scantic–Broad Brook area. In 1631, Chief Wahginnacut invited the English to come and settle in the Connecticut valley.

In the 17th century, several Windsor families regularly crossed the Connecticut River to maintain farms or to graze livestock on the east side, then known as Windsor Farms. However, they kept homes on the west side.

Francis Stiles, one of the early Windsor settlers, purchased a mile of land along the east side of the river from an Indian sachem in the early 1600s. The tract in the Warehouse Point area extended east from the river for three miles and later became Saltonstall Park. The area was valuable because it was convenient for unloading ships that were unable to make their way beyond the Enfield Falls to the north. Goods bound for Springfield and Boston were frequently stored in the area, which became the site of a warehouse built by Springfield merchant William Pynchon.

Other Windsor landowners continued to farm the meadows in the areas just north and south of the Scantic River, and gradually some established temporary, then permanent, homes just east on higher ground. By 1680, there were enough eastside residents to petition the colonial government for permission to establish their own church to eliminate the hardship of attending Congregational services in Windsor. The older church opposed that and later petitions, but the Connecticut General Court finally allowed a new society in 1694. The Rev. Timothy Edwards was the first minister of the parish in the town of South Windsor. His son Jonathan Edwards later became a leader in the Great Awakening religious revival.

Another eastside church society was established in 1735 in the Ellington area, followed by one in Scantic in 1752 and another in Wapping in 1761. Most of the cleared land was used for farming, but small mills dotted the rivers and streams throughout the area.

Within a few years, the eastsiders began seeking to form their own town, a move approved in 1768. The newly incorporated East Windsor then included all of Ellington and South Windsor. Their struggles for independence from Windsor may have made East Windsor residents more receptive to the early calls for American independence from England. A town meeting in August 1774 resulted in a resolution opposing the Townshend Acts, which had replaced the earlier, repealed Stamp Act, and establishing a committee of correspondence, which later became a more radical committee of safety.

In 1775, the committee collected supplies to relieve the blockaded citizens of Boston. The new town played an important role in the American Revolution as a provision town. Israel Bissell, an East Windsor resident and young post rider in 1775, was on his rounds on April 19 and was pressed into service to warn residents of the area around Watertown and Worcester, Massachusetts,

about the events of Concord and Lexington. He followed his normal route through Connecticut to New York, stopping at many shoreline towns to warn the populace. At breakneck speed, he continued through New York and New Jersey, stopping only when he reached Philadelphia, where the continental leaders had been meeting.

East Windsor's response was immediate. Militiamen were summoned, and within hours, some 150 marched to aid their counterparts in Massachusetts. The men gathered in four train bands, one from each parish in East Windsor. Most returned after a couple of days when informed that the battles had ended, but some continued to Boston.

One train band member went on to become a hero of the Revolution. Elijah Churchill, born in New York, was in the South Parish group. Upon returning to East Windsor, he joined the Continental Army, becoming a sergeant in the Connecticut Light Dragoons, a crack cavalry group involved in reconnaissance and raids in Connecticut and New York during much of the war. He led sneak attacks at Fort St. George and Fort Slongo, New York, resulting in the capture of valuable supplies for the American troops and the destruction of those needed by the British. On the home front, East Windsor continued to supply food and other necessities along with a large number of soldiers.

Before the Revolution, tobacco had become an important crop in the Connecticut River valley. By 1750, prominent East Windsor families like the Bissells, Ellsworths, Wolcotts, Grants, Talcotts, and others were growing tobacco widely, while many farmers were growing a few plants for chewing. Within a decade, it became a major crop, with some farmers exporting it to the West Indies.

Cigars became popular in America after Col. Israel Putnam brought back a chest of Havanas from Cuba in 1762. One account credits a Mrs. Prouty of East Windsor with being the first in America to produce the "long nines," a long, thin cigar, in 1801. She may have been the widow of a man named Prout, who is said to have made them earlier in a shanty near what is now Route 5, in the area of the Scantic River. About the same time, Horace Filley of East Windsor set up his own shop to manufacture "short sixes" and other types of cigars.

During the post-Revolutionary period, the area also spawned dozens of artisans and craftsmen. Silversmith and clock maker Daniel Burnap operated in East Windsor Hill, as did the better-known Eli Terry. At the same time, a half dozen shipbuilders plied their trade near the mouth of the Scantic River.

East Windsor lost a third of its area in 1786 when Ellington became a separate town. The 1790 census indicated 2,600 people remaining in what are now East Windsor and South Windsor. By 1840, the number grew to 3,600. Five years later, South Windsor was incorporated, setting the present boundaries of the towns.

Agriculture continued to dominate East Windsor in the 19th century. By the time of the Civil War, some home industries grew into businesses, mills continued to expand, and brickmaking was thriving. As they had during the Revolution, East Windsor men exceeded state and national quotas for volunteers in the Civil War. From a town population of 2,580, more than 300 men joined Union forces, and about 40 died in service. Although some veterans migrated west, most returned here to live.

During World War II, more than 400 men and women from East Windsor served; the population then was about 4,000. The postwar period brought the town's great influx. Growing industry, low-cost housing, and veterans' financing combined to push the population to 7,500 by 1960 as the five villages of the town became less distinct.

The last few decades have seen slow, steady changes in East Windsor. Agriculture, particularly tobacco, potatoes, and nursery stock, remains an important part of the economy, particularly in Broad Brook, Melrose, and Windsorville, but industrial and commercial uses of the land continue to grow, mainly in Warehouse Point, with Scantic remaining generally residential. Recent population growth has been slow, with current estimates at about 11,000 people.

—Michael J. Salvatore

One

THE VILLAGE OF WAREHOUSE POINT

Its location on the east side of the Connecticut River just south of the Enfield Falls shaped this village into a river port. In 1636, William Pynchon, a founder of Springfield, Massachusetts, wanted Boston goods shipped by water up the Connecticut River. Since the Enfield Falls were an obstruction, the boats were unloaded just south of the falls. A warehouse was built to store the goods until they could be carted overland the 14 miles to Springfield or loaded on boats north of the falls to continue their journey. It is unclear where the warehouse actually stood, but from that time on, the village was known as Warehouse Point. The millers and farmers of the surrounding area were able to move their products using the "river road." In his 1889 diary, Lemuel Stoughton writes:

> Standing on the riverbank opposite here and a good south wind blowing, I have counted coming up the river some times ten or twelve flatbottom boats with mainsail and topsail all spread to the breeze driving on against the stream at from three to five miles the hour as the strength of the wind might be.

Because of the boat traffic and the ferry-crossing to Windsor Locks, travelers and river men needed accommodations. The village had several hotels, including the American, the Windsor, and the Saltonstall, to name three. Many businesses and services were developed to support the village, such as the East Windsor Woolen Company Mill (later the Leonard Silk Mill); J.S. Palmer Dry Goods and Grocery, later Boleyn's store; A.P. Filer, lumber dealer; Palmer, box manufacturer; Bush, wagon manufacturer; Gage, carpenter and builder; and Fisk, physician and surgeon. A few of the prominent men—Gen. Charles Jenks, Colonel Phelps, Harvey Holkins, and Horace Barber—engaged in distilling the rye and corn that was grown so prevalently in the area, each owning a distillery.

The trolley system played a large role in village development. Now people could travel not only on the river but also on a trolley car north to Springfield and beyond and south to East Windsor Hill and on through Hartford. In 1897, the first trolley car in East Windsor ran from Springfield to Warehouse Point every hour from 7:00 a.m. to 10:00 p.m.

Today, the bustle of the boats and trolleys has been replaced by trains, trucks, and automobiles, but Warehouse Point has managed to change with the times and continues to be a valuable part of East Windsor as its center of commerce and industry.

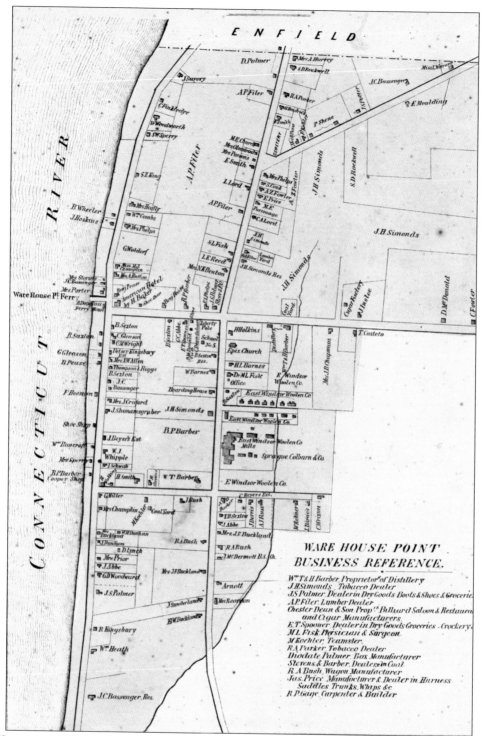

WAREHOUSE POINT MAP, 1869. By this time, the village of Warehouse Point was well populated with industries, as noted on the map. The ferry was still in operation, but trolley service did not arrive until 1897.

10

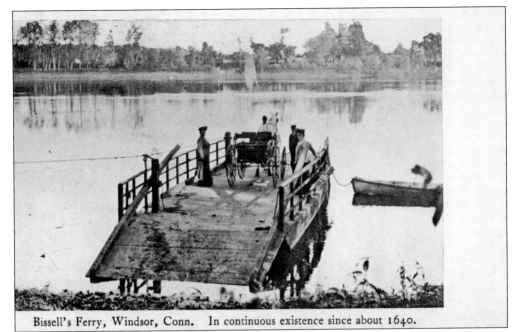

Bissell's Ferry, Windsor, Conn. In continuous existence since about 1640.

BISSELL FERRY. In 1641, John Bissell was granted permission by the Connecticut General Court to operate a ferry line from north of the Scantic River at Quarry Wharf, East Windsor, to Windsor. After paying a toll, travelers and livestock alike rode the ferry. Since the approach was down high banks and flooded often, the ferry service was moved in 1677 to Ferry Road. It operated until 1917. (Courtesy of Keith Cotton.)

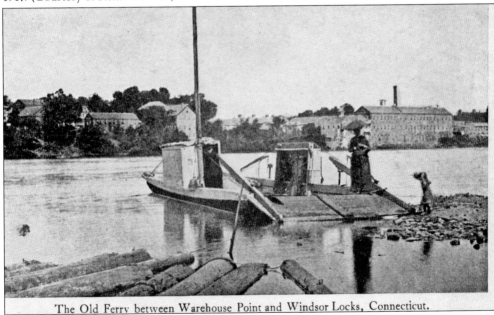

The Old Ferry between Warehouse Point and Windsor Locks, Connecticut.

THE OLD FERRY. In the 1600s and 1700s, ferries were the only means for the public to cross the Connecticut River. In 1783, sixty-one villagers joined Samuel Watson to petition the General Court for a ferry from Warehouse Point to Windsor Locks. The ferryboat was poled across and secured to a pier in the river to keep it from being washed downstream.

11

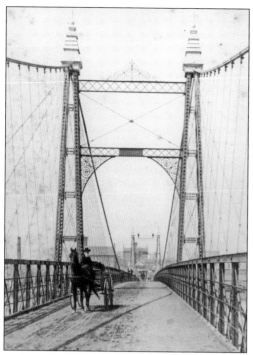

Toll Bridge. Progress for Warehouse Point was made when a bridge was built to replace the ferry. In 1886, the Windsor Locks and Warehouse Point Bridge and Ferry Company erected a three-span suspension toll bridge over the river. In 1907, the State of Connecticut purchased the bridge, making it the first toll-free bridge across the Connecticut River in the state. Driving the buggy is Milton Bancroft.

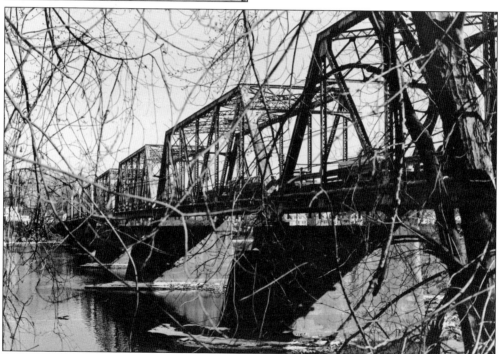

Suspension Bridge. With the increase in traffic, especially truck traffic from the region's tobacco fields, the old toll suspension bridge became unsafe and obsolete. The state hired the Berlin Construction Company to replace it with this seven-span through Pratt truss structure. Opening in 1921, this Bridge Street bridge was in use until 1992, when it too was replaced, this time with a two-lane girder bridge.

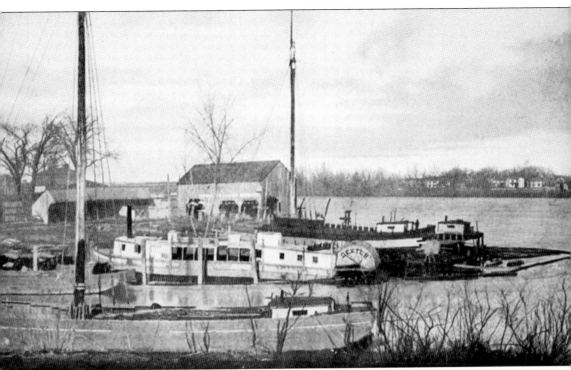

RIVER BOATS. The Connecticut River cuts through the middle of New England. Early settlers in towns all up and down the river used it to transport their goods as far away as the West Indies in the Caribbean. East Windsor was no different. Flat-bottom boats were largely used to run the rapids of the Enfield Falls, and the first steamboat to ascend the river over the falls was the *Barnet*. In the early 1700s, Ebenezer Grant operated a shipyard at the mouth of the Scantic River, building brigs with two masts and ships with three masts or more, all square rigged, with names like *Hariott*, *Freman*, *Heroine*, and *Luna*. The Revolutionary War caused the end of this business. The *Charles H. Dexter*, shown at the Dutch Point dock in Hartford in 1886, was the last steamboat to operate on the Connecticut River north of Hartford to Warehouse Point. (Courtesy of Hartford National Corporation Records, Archives and Special Collections, University of Connecticut Libraries.)

WINDSOR HOTEL. Warehouse Point was an important inland port for river men and travelers; consequently, several hotels were in operation there. The Windsor Hotel stood on Bridge Street next to the Saltonstall Inn. When it burned to the ground in 1909, the village decided it was time to establish a fire department and purchase equipment. Up to this time, fires were extinguished by bucket brigades or calling the Windsor Locks Fire Department. (Courtesy of Warehouse Point Library.)

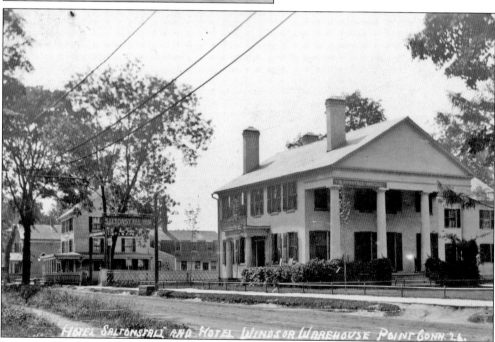

SALTONSTALL INN. Although the Greek Revival style was common among Warehouse Point buildings, this residence with its five-bay facade and colonnade stands grander than its neighbors. It was built about 1850, and B.P. Barber owned the property. At the time, he ran one of the village's four distilleries. In 1880, it was the Point Restaurant, and at the beginning of the 20th century, it became the Saltonstall Inn.

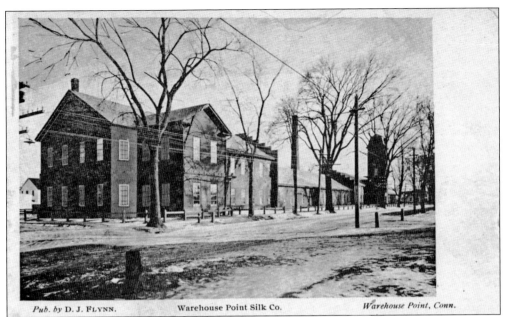

LEONARD SILK COMPANY. In 1870, Jehiel Simonds and J.N. Leonard purchased an 1804 woolen mill at 132 Main Street and converted it to silk manufacturing. Using raw Japanese silk, it made sewing thread. After a major fire in 1874, Leonard sold most of the occupied mill workers' houses to build a new factory made of brick and equipped with a sprinkler system. To accomplish this, a large tank was installed in the bell tower. Water was pumped from storage tanks into the tower tank, and gravity fed the sprinklers. By the mill's closing in the 1940s, it employed 200 workers. Leonard thread was sold throughout the country. During the 19th century, silk manufacturing was Warehouse Point's second largest business, following only gin distilleries.

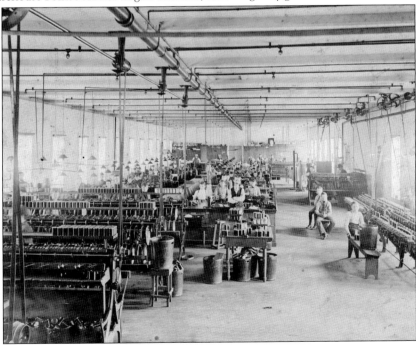

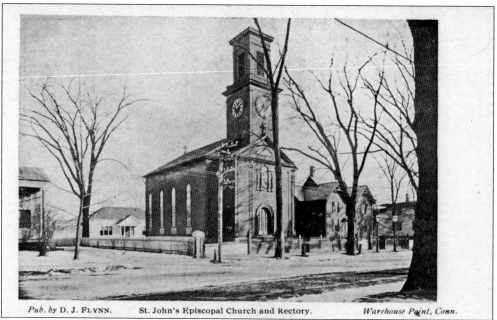

Pub. by D. J. FLYNN. St. John's Episcopal Church and Rectory. *Warehouse Point, Conn.*

ST. JOHN'S EPISCOPAL CHURCH AND RECTORY. In 1802, seventy residents of Warehouse Point requested Rev. Menzies Raynor to be minister for their parish group. At the time, Reverend Raynor was rector of Christ Church in Hartford. In 1809, the original church structure was built on the village green. It was moved to its present site in 1844, when it was remodeled and enlarged. The church rectory was completed in 1885.

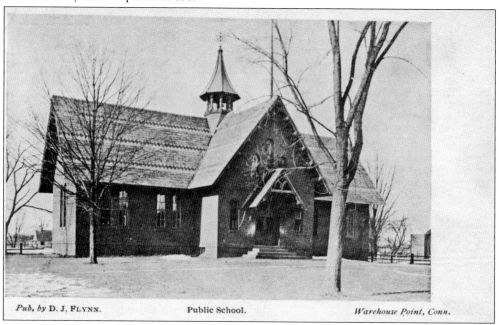

Pub. by D. J. FLYNN. Public School. *Warehouse Point, Conn.*

WAREHOUSE POINT SCHOOL. According to early state laws, once a district had 70 families, it was required to support a school. Warehouse Point reached that requirement in 1789 and became District 5. A schoolhouse was built on the southwest corner of the village green. It was replaced by this Gothic cruciform structure in 1874 on School Street. Over time, many additions changed its look.

16

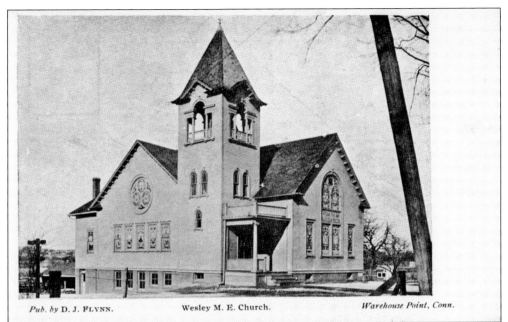

Pub. by D. J. FLYNN. Wesley M. E. Church. *Warehouse Point, Conn.*

WESLEY METHODIST EPISCOPAL CHURCH. Although there was a Methodist society as early as 1814 in Warehouse Point, they did not have a permanent building until 1832. Two structures have served as their house of worship. The first was located on North Main Street opposite the cemetery and served as a church from 1832 until 1899, when the present church was erected. The eclectic design with stained-glass windows and distinctive bell tower is seen nowhere else in the village.

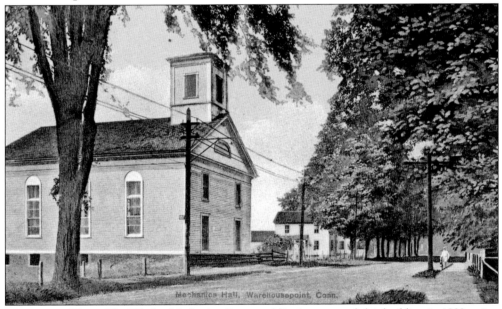

MECHANICS HALL. The Wesley Methodist Episcopal Society erected this building in 1832, using it until a larger church was needed and built. Liberty Council No. 36, Order of United American Mechanics, purchased it in 1900, hence the name Mechanics Hall. It stood on North Main Street opposite the old cemetery. Dances, benefits, firemen banquets, civic meetings, and other events were held here from 1900 until it was demolished in 1940.

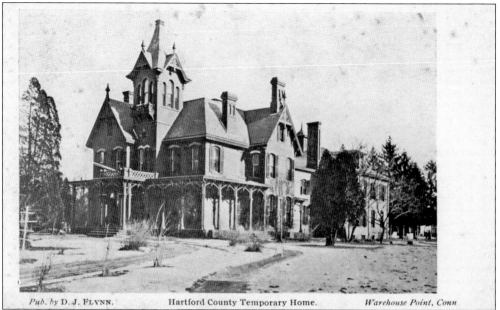

Pub. by D. J. FLYNN. Hartford County Temporary Home. *Warehouse Point, Conn*

GARDNER MANSION, STATE RECEIVING HOME. This 1918 postcard shows the 16-room brick residence at 36 Gardner Street built in 1847 by author Avah Gardner. In 1889, Hartford County purchased it along with 11 acres for an orphanage. It was originally called the Hartford County Temporary Home for Neglected and Dependent Children. Over time, many buildings have been added to perform this function, and it now serves the entire state.

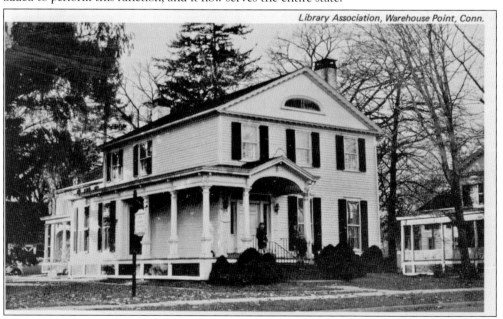

Library Association, Warehouse Point, Conn.

WAREHOUSE POINT LIBRARY. The Library Association of Warehouse Point was founded in 1811 with 200 books donated by the citizens. In 1909, patrons no longer had to pay a yearly fee because the Town of East Windsor voted to help fund the library, and it received several bequests in the following years. The library was located at several sites until, in 1937, the Finley Estate property at 107 Main Street was purchased, giving it a permanent home.

FIFE AND DRUM CORPS. The Warehouse Point Fife and Drum Corps was established in 1880 and was made up of Civil War veterans. The men wore colorful green uniforms trimmed with gold and white braid. Members pictured here are, from left to right, (first row) E. Parsory and Maj. Sidney A. Boleyn; (second row) Albert J. Frey, John A. Frey, C. Bassinger, Henry Mohn, F. Trombly, and Robert E. Frey; (third row) Fred W. Vehring, D.J. Kilty, Michael F. Kilty, and C. Cadwell. (Courtesy of Warehouse Point Library.)

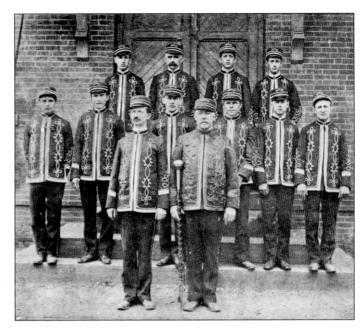

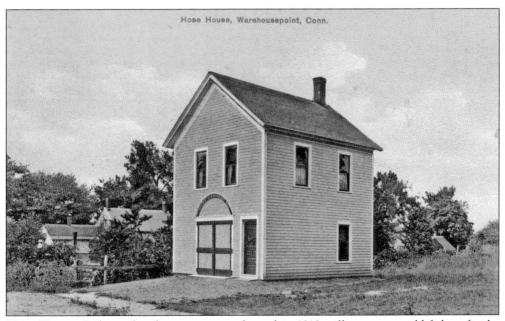

HOSE HOUSE. Before a fire department was formed in 1910, village men would fight a fire by forming a bucket brigade from the nearest water supply. The Warehouse Point Village Improvement Society changed that by building a hose house on School Street and supplying it with hoses and two hose carts. The first department consisted of 24 men. The building was lengthened and a bell tower added in 1916. (Courtesy of Connecticut Trolley Museum.)

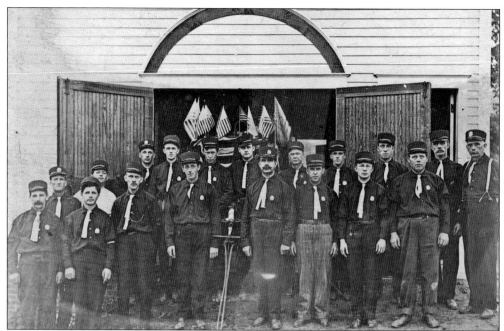

WAREHOUSE POINT FIRE DEPARTMENT. In 1910, the Warehouse Point Village Improvement Society established a fire department. Members of the first department are, from left to right (first row) Eugene Juckett, John Norris, Charles Bassinger, Walter Price, Dennis Flynn (chief), John Calahan, John Karges, and Patrick Landers; (second row) William Coleman, Michael Kilty, Fred Vehring, Frank House, John Barry, William Bromage, John F. Flynn, Frank Koehler, Frank Blaney, Charles Blaney, and Dennis Kilty. (Courtesy of Warehouse Point Fire Department.)

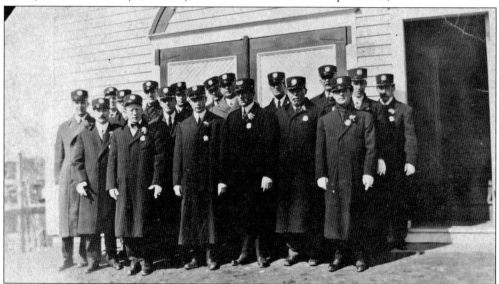

WAREHOUSE POINT FIRE DEPARTMENT, 1911. Pictured are the efficient firefighters known as Volunteer Hose No. 1. From left to right are Eugene Juckett, John Norris, Dennis Flynn, John Karges, William Coleman, Fred Vehring, John Barry, Frank Blaney, William Kilty, Charles Bassinger, Walter Price, John Callahan, Patrick Landers, Michael Kilty, Frank House, William Bromage, Charles Blaney, and John Flynn.

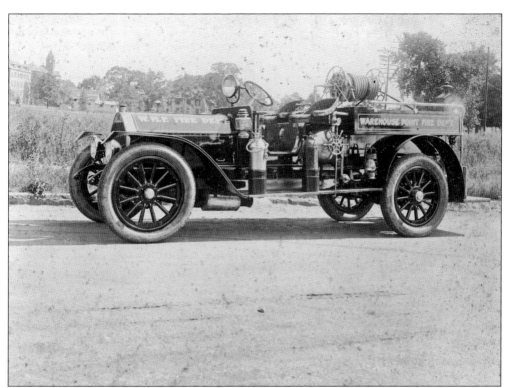

First Motorized Fire Truck. In 1917, this right-hand-drive Knox hose and chemical truck was purchased by the Warehouse Point Fire District. The body was built by the Springfield Body Works, and it was the department's first motorized fire apparatus. Housed at the hose house on School Street, this truck could go places in a hurry. Knox was a leading name in motorized fire apparatus in the early years of the 20th century.

North End Fire Station. About 1927, the Warehouse Point Fire Department purchased a wooden building from the State Receiving Home on Gardner Street and moved it to North Main Street to serve as a second station. Shown housed in the North End Station is a 1947 Howe-Dodge fire truck with a capacity of pumping 500 gallons per minute. It was purchased by the department in 1947. (Courtesy of the Warehouse Point Fire Department.)

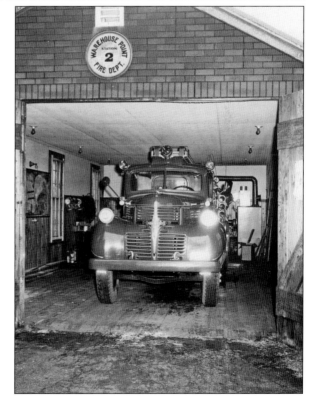

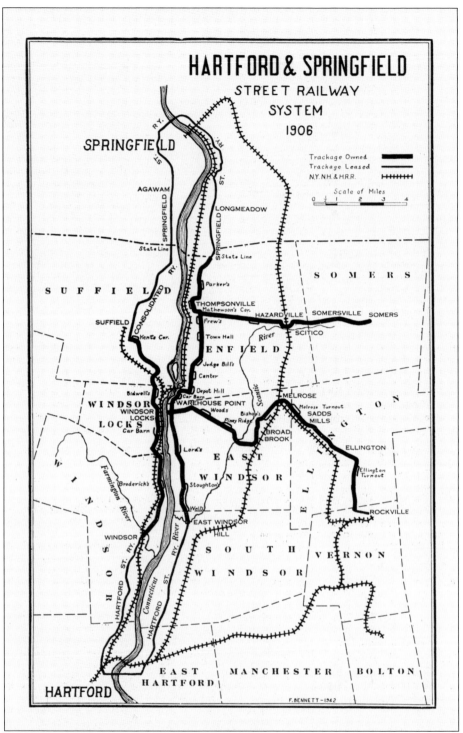

Trolley System Map. The trolley system became quite extensive. Lines were added as ridership demanded. This 1906 map shows only the Hartford and Springfield area. (Courtesy of Connecticut Trolley Museum.)

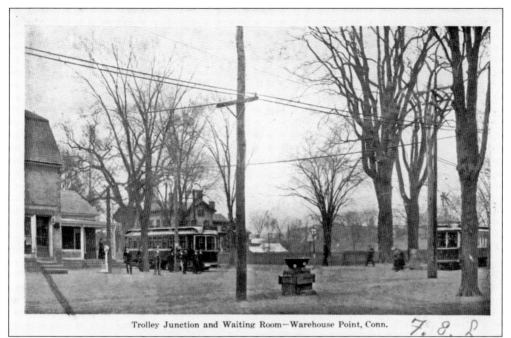

Trolley Junction and Waiting Room—Warehouse Point, Conn. *7. 8. L*

BOLEYN'S CORNER. The building at the northwest corner of Bridge and Main Streets consists of a two-story block and a one-story addition. Built in the early 1800s, it is one of the oldest commercial buildings in Warehouse Point. In the later 1800s, Boleyn's General Store, the post office, and the Warehouse Point Library shared this space, and the corner became known as Boleyn's Corner. This building played a significant part in East Windsor's trolley transportation history. It was the waiting room for the trolley line from Springfield. The first trolley arrived Sunday, January 3, 1897, and by the end of 1906, the trolley system went all the way to Rockville and beyond. The photograph above shows the Jehiel Simonds mansion on the northeast corner (behind the trolley car). Jehiel Simonds owned the Leonard Silk Company on Main Street. (Above, courtesy of Paul Anderson; below, courtesy of At the Dam Restaurant.)

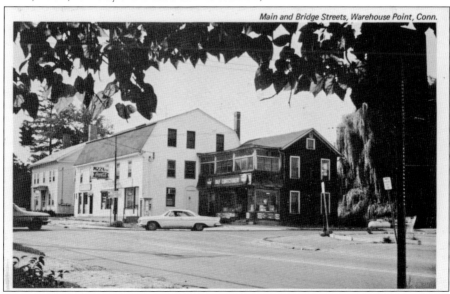

Main and Bridge Streets, Warehouse Point, Conn.

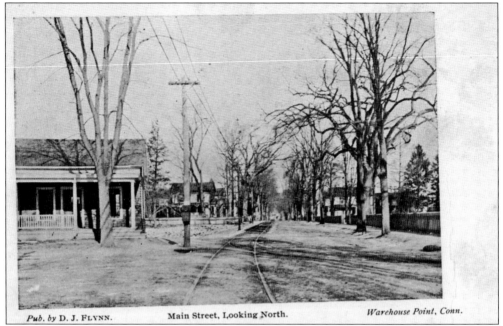

Pub. by D. J. FLYNN. Main Street, Looking North. *Warehouse Point, Conn.*

MAIN STREET, NORTH. This postcard shows Main Street from Bridge Street looking north. The Boleyn's Corner trolley stop is on the left. The tracks down the street are heading to Enfield and then on to Springfield, Massachusetts. When the service opened in 1897, the trolleys ran every hour from 7:00 a.m. to 10:00 p.m. to Springfield with a fee of 15¢.

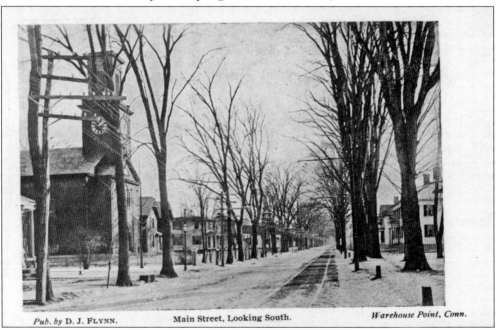

Pub. by D. J. FLYNN. Main Street, Looking South. *Warehouse Point, Conn.*

MAIN STREET, SOUTH. This view shows Main Street from Boleyn's Corner at Bridge Street looking south. St. John's Episcopal Church stands prominently in the left foreground. The trolley tracks running down the street are part of the Warehouse Point–to–East Windsor Hill line that was opened in 1897 by the Hartford & Springfield Street Railway Company.

Boleyn's Brook, 1897. The trolley bridge was constructed over Boleyn's Brook running alongside the old road on North Water Street near the Enfield town line. This allowed the trolley to travel to Boleyn's Corner in Warehouse Point on its way from Springfield. The brook empties into the Connecticut River. (Courtesy of Warehouse Point Library.)

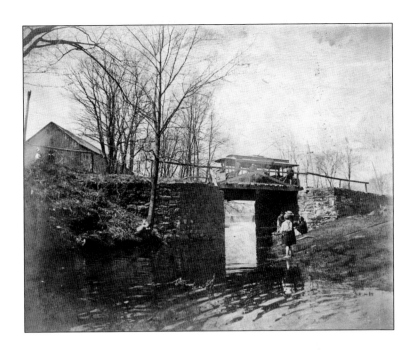

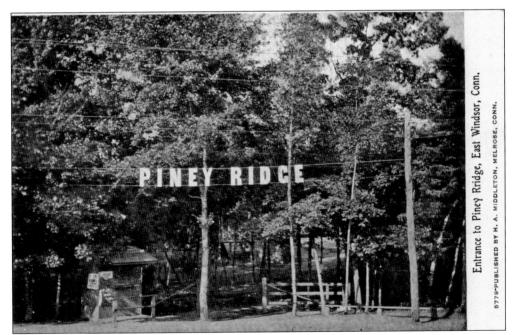

Piney Ridge Park. To boost ridership, the Hartford & Springfield Company purchased an eight-acre tract of land on the trolley line between Warehouse Point and Broad Brook in February 1906 for picnickers and pleasure seekers during the summer. Since the area was covered with pine trees, the name became Piney Ridge Park. (Courtesy of Keith Cotton.)

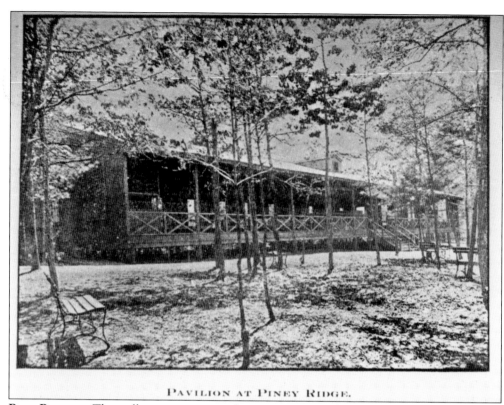

PAVILION AT PINEY RIDGE.

PARK PAVILION. The trolley company spared no expense to make Piney Ridge a popular resort. The pavilion was 144 by 46 feet in size, accommodated up to 300 couples, and had the most up-to-date lighting so dances could be held at night. Moving pictures could be shown from a cupola onto a large screen stretched in front of the pavilion. Concerts, band competitions, and minstrel shows from well-known bands and acts from all over were held. A roller-skating rink was added in 1907.

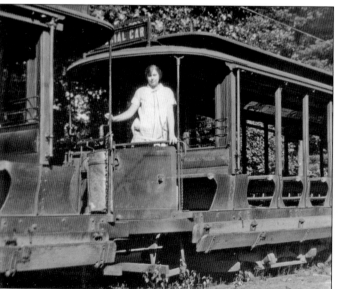

TROLLEY LINE TO PARK. Car No. 42 is shown on a scrap line at the Piney Ridge Park siding in 1926. When the park opened on Memorial Day 1906, the attendance was up to 1,500 by the evening. Large numbers of riders came throughout the years to hear bands such as the Governor's Foot Guard Band of Hartford or watch an amateur or semipro baseball game with players like Babe Ruth and Lou Gehrig before they were in the major leagues. (Courtesy of Connecticut Trolley Museum.)

INDEPENDENCE DAY, 1916. In the early 1900s, there were only three major holidays: Christmas, Thanksgiving, and the Fourth of July. With the weather warm and spirits high, the Fourth offered the opportunity for people to get together and really celebrate. Parades were the high point, with horse-drawn carts decorated into floats by various clubs, societies, fraternal organizations, and schoolchildren.

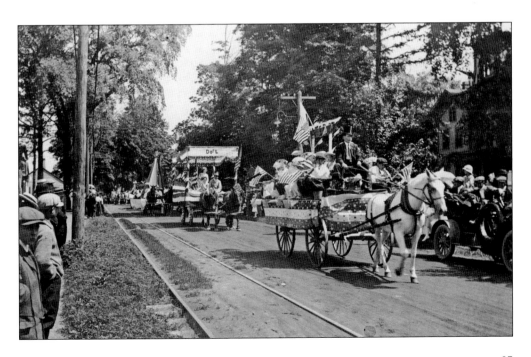

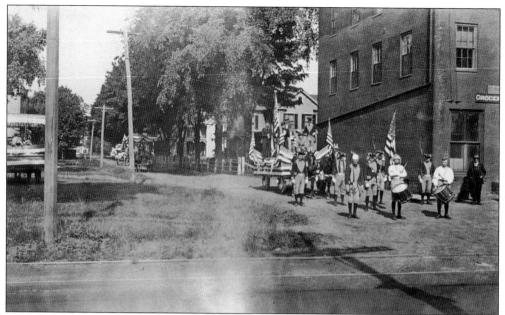

INDEPENDENCE DAY, 1916, CONTINUED. A typical parade would assemble at School Street, march north on Main Street to the cemetery, regroup, and march south on Main Street to the Springdale Cemetery. Here, the Warehouse Point Fife and Drum Corps, established in 1880, starts off the parade on School Street.

WELCOME HOME WORLD WAR I, WAREHOUSE POINT. On August 9, 1919, East Windsor honored service members from Warehouse Point and Scantic with a welcome home celebration. Festivities started with a parade and ceremonies on the village green, where this photograph was taken. Later, at Piney Ridge Park, events continued with a dinner, moving picture show, and dancing until midnight. (Courtesy of Warehouse Point Library.)

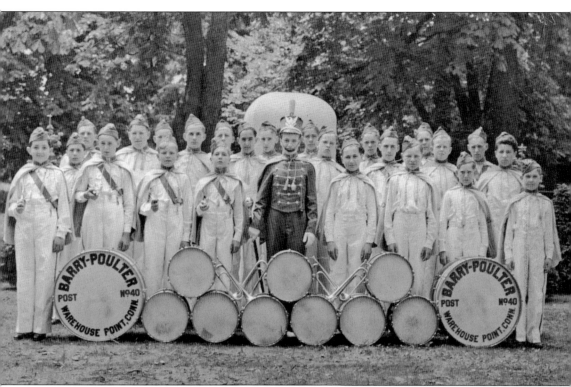

DRUM AND BUGLE CORPS. Although organized in 1919, the Barry-Poulter Post No. 40 of Warehouse Point was issued a national charter in 1926. Named in honor of two East Windsor men who gave their lives during World War I, Patrick J. Barry and James Poulter Jr., the organization works for the benefit of veterans to help with their rehabilitation. The post is shown here on May 30, 1938, after a Memorial Day parade. From left to right are (first row) Herbert Tschummi, George Wadsworth, Michael Yosky, Charles Steitz, George Hall (drillmaster), Anthony Detommaso, John Cuskavitch, Raymond Callanan, and Raymond Steitz; (second row) Michael Pappagallo, Joseph Lichenberg, Francis Boroski, Jerome Herrick, William Cooper, Edward Bourke, Everett Boyle, and John Polozie; (third row) Kenneth Allen, Walter Wadsworth, Frank Koehler, Francis Fay, James Perkins, Francis Wilcox, James Allen, and Harold Wadsworth.

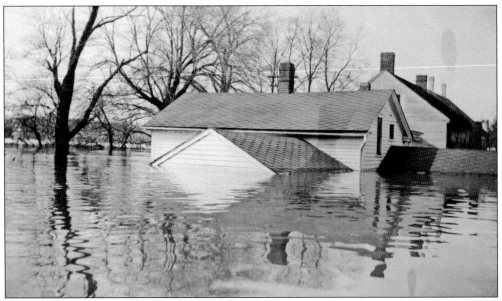

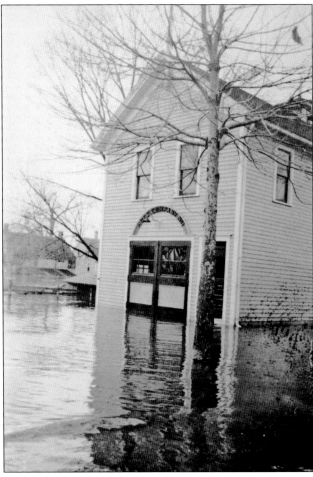

FLOOD, 1936. It was the greatest disaster ever recorded along the Connecticut River. Fourteen days of rain pounded New England beginning on March 11, 1936, unleashing a flood that covered half of the eastern United States. A winter of heavy snowfall, an early thaw, and torrential rains burst dams, wiping out roads, ruining businesses, and washing away homes. The Warehouse Point section of East Windsor was hit hard. Above is the Palmer house on the corner of School and South Water Streets submerged up to its roof. At left is the Warehouse Point Fire Department hose house on the corner of School Street and Dean Avenue surrounded by the floodwaters.

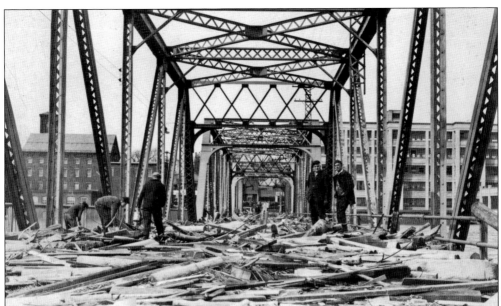

FLOOD, 1936, CONTINUED. The Connecticut River floodwaters rose to 38 feet in Hartford, a record. Above, the Bridge Street bridge decking was destroyed by the surging water that roared over it. When it was over, the river appeared more like a lake. The property damage was huge. The commercial building on the corner of Main and School Streets was inundated with water. Vining's Market, the town library, and the post office were housed here at the time. The disaster caused Congress to act. In June 1936, Pres. Franklin D. Roosevelt signed the Flood Control Act of 1936. It authorized the US Army Corps of Engineers to build hundreds of miles of levees, flood walls, and channel improvements and about 375 major reservoirs to help alleviate flooding in the future.

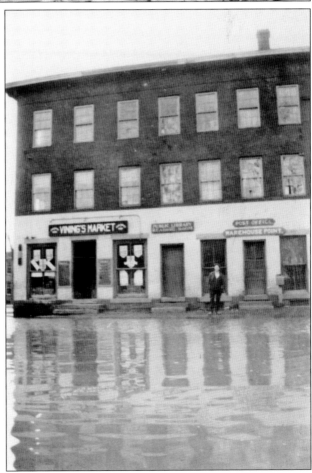

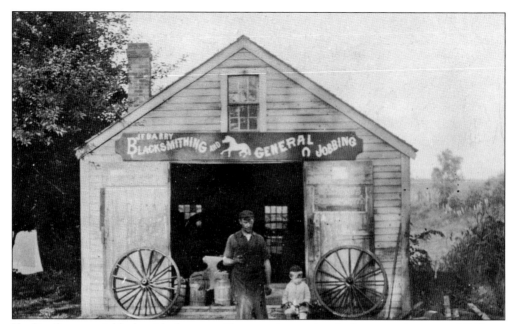

YE OLE SMITTY. A blacksmith shop was like a service station for horses and wagons. J.F. Barry Blacksmithing was located on Main Street and was owned and operated by John F. Barry and his son for over half a century. The next generation restored it, only to lose it to a suspicious fire in 1986. John Barry and his son, David Patrick, pose in front of the shop in 1905. (Courtesy of Warehouse Point Library.)

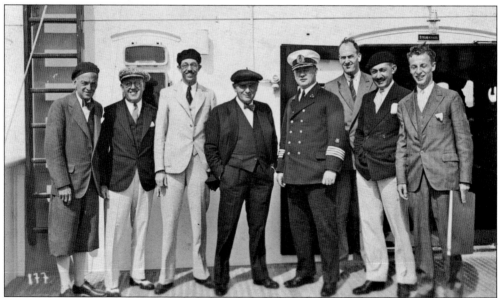

RADIO PIONEER. Oscar B. Hanson of East Windsor was a pioneer in radio and television and ranks among the greatest of the first generation of broadcast engineers. When the National Broadcasting Company was formed, he became director and vice president of technical operations. He wired the Metropolitan Opera House for sound and designed the controls at Radio City. He is buried in Springdale Cemetery in Warehouse Point. A note on this photograph reads, "Going to build Radio City." Hanson is third from the left.

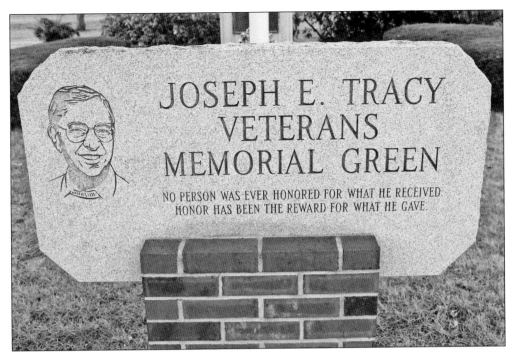

**THE MAN WHO SAVED MEMORIAL
DAY.** On Memorial Day 1994, the
Warehouse Point Veterans Memorial
Green was dedicated to Joseph E.
Tracy. His plaque inscription reads,
"No person was ever honored for
what he received. Honor has been the
reward for what he gave." Growing
up in Warehouse Point, Tracy was a
lifelong volunteer and was dedicated
to the town. His contributions are too
numerous to list, but include 37 years
on the fire department, 41 years with
Barry-Poulter Post No. 40, and 40 years
organizing the town's Halloween party.
During the 1960s, when patriotism was
scorned and participation dwindled,
East Windsor contemplated foregoing
the Memorial Day celebrations. It was
through Tracy's efforts that Memorial
Day celebrations continued, and for
30 years, he organized the town's
celebrations so that no veteran who
died in combat would be forgotten.

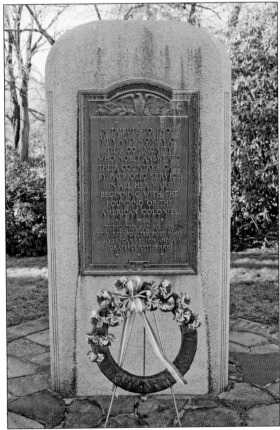

BICENTENNIAL. In May 1968, the town commemorated its 200th anniversary with a three-week celebration. There were many events, historical pageants, rides and amusements, a Bavarian beer garden, square dancing, a grand ball, election of a bicentennial queen, and fireworks. The highlight of the celebration was the grand parade, which included all the town organizations and musical bands. Outsiders, such as the nationally famous John Ferko Mummers String Band from Philadelphia (below) and the 1st Company Governors Foot Guard from Hartford, joined in the march down Route 5. The parade marshal and president was L. Ellsworth Stoughton, founding president of the East Windsor Historical Society in 1966, affectionately known as "Mr. East Windsor."

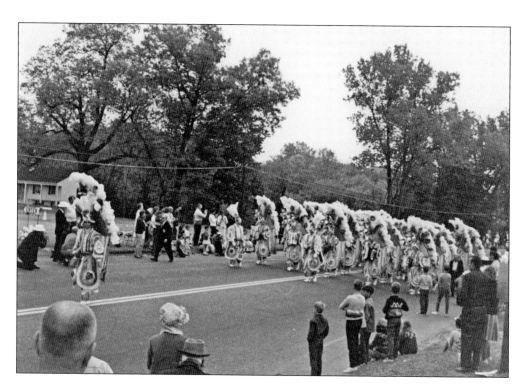

Two

THE VILLAGE OF SCANTIC

The first settlers of East Windsor primarily populated the Route 5 and Scantic River area, moving eastward to the Scantic territory in the early 1700s. The Native Americans who inhabited the area were a clan of the Podunk tribe called the Skeantockes (spelled different ways), meaning "mingling of the waters;" this was shortened to Scantic.

Although families had cleared land and built homesteads earlier, the community actually started in 1752, when the Connecticut General Court at Hartford recognized the settlers living north of the Scantic River as their own ecclesiastical society. The village grew around the church and its membership. Then called the Second Congregational Church of East Windsor, the parish became the center for not only the flock's spiritual life but also the town's civic life. Its committee laid out the school districts, established the East Windsor Library, and purchased land for cemeteries. Town meetings were held in its hall from 1768, when East Windsor was separated from Windsor, until about 1916.

Ecclesiastical control of public education in Connecticut came from the first settlers' intense concern for education, which they placed second only to religion. The Ecclesiastical Society of East Windsor defined and set off 12 school districts to accommodate the needs of an increasing population and operated them for a century before relinquishing control of the schools to town management. The Scantic Academy, the town's first school for higher learning, was erected for the Ecclesiastical Society in 1817.

Although the church never organized for war purposes, it has contributed to the national defense in other ways. The meetinghouse was the focal point for a rallying to arms in 1775. After the battle at Lexington, 45 local militiamen gathered on the village green to join the fight in the Revolutionary War. Of these, 12 are buried in the Scantic cemetery and five in the Town Street cemetery on Route 5. Civil War reunions were held in the hall, and during World War II, the meetinghouse was the main evacuation center if any bombing occurred in East Windsor or cities nearby.

Large family farms once dotted the land in the village of Scantic. Today, a drive through its streets shows new residences alongside surviving historical homesteads. Views of pasturelands and hobby-horse farms with riding and boarding facilities meet the eye. Tilled soil for crops, rolling hills, and empty acreage still exist. Through it all, the stately First Congregational Church still stands where it all started, in the center next to the little village green.

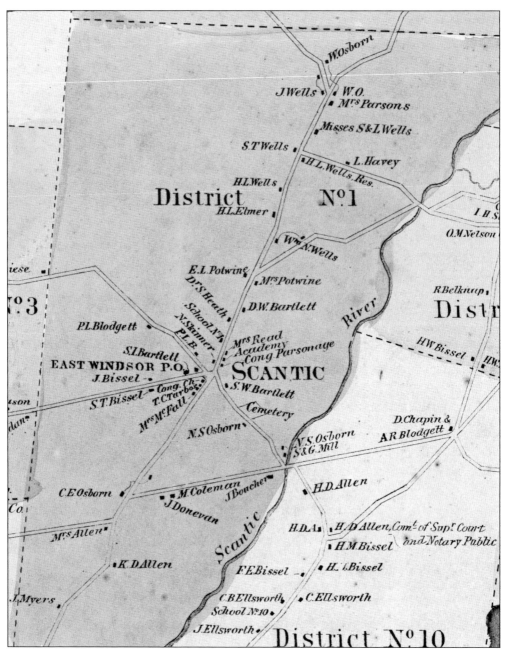

Scantic Map, 1869. At the time of this map, the First Congregational Church was the center of village life. From this center, the parsonages, farms, residences, schools, gristmill, and post office branched out.

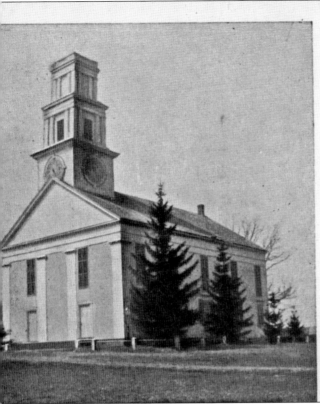

First Congregational Church,
East Windsor, Connecticut.

THE FIRST CONGREGATIONAL CHURCH OF EAST WINDSOR. The first and oldest parish society in East Windsor was established in 1752 in Scantic. A lot on Samuel Watson's land was chosen as the center of the parish, and a meetinghouse was built. No longer would the parishioners have to cross the river and endure hours of travel to attend services in Windsor. The membership was very devoted, and as a result, 17 ministers and missionaries were born or raised in the Scantic parish. They went as far away as Hawaii and China. The church also has the honor of claiming two of the earliest women missionaries in the nation, Carolyn Bartlett and Nancy Wells Ruggles. The meetinghouse was destroyed by a suspicious fire in 1802, and a larger meetinghouse was completed in 1804. Shown in 1906, this Greek Revival country church still stands at the intersection of Scantic, Phelps, Tromley, and Cemetery Roads. (Courtesy of Keith Cotton.)

REV. SHUBAEL BARTLETT. The second pastor of the First Congregational Church served for over half a century. He had a strong social instinct and was very involved with his flock, visiting and being visited by young and old. Born in Lebanon, Connecticut, in 1778, Bartlett's ancestry can be traced to John Alden of the *Mayflower*. Graduating from Yale, he started his ministry with the church in 1804. He married Fanny Leffingwell of Hartford and raised his family in their home on Scantic Road until his death in 1854.

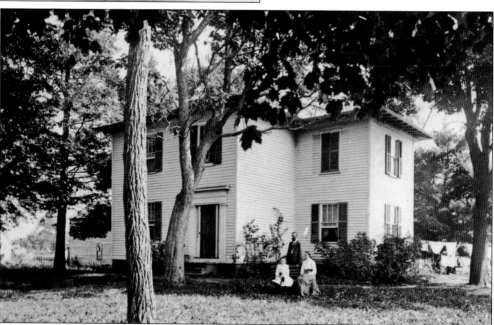

THIRD PARSONAGE. This house served as the third parsonage for the First Congregational Church from the time it was built in 1849 until it was sold in 1945. It is the only example of Italianate-style architecture in the village of Scantic. Rev. William and Janet English and their daughter, Margaret, are in the foreground. Reverend English was a former missionary in Turkey who came to Scantic in 1892 to recover his health.

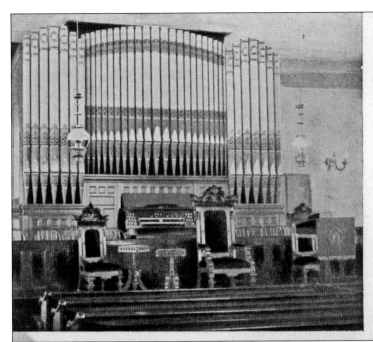

Interior of
First Congregational
Church,
East Windsor,
Connecticut.

PIPE ORGAN, FIRST CONGREGATIONAL CHURCH. This tracker pipe organ, with five ranks and a total of 1,341 speaking pipes, was donated to the church by Adelaide F. Colton in 1895. To accommodate the organ, the choir loft was moved from the rear to the front of the sanctuary. Before the church was electrified in 1919, the organ bellows needed to be manually pumped. These organ pumpers were referred to as "blow boys."

CELLIST, FIRST CONGREGATIONAL CHURCH. Before the first organ was introduced into the church in 1868, Maj. Samuel Williams Bartlett (1810–1891) accompanied the congregation with a cello. Major Bartlett was an accomplished musician who served in the 25th Regiment Infantry of the militia and in the drum corps. Living on his farm across the street from the church, he bred pedigreed livestock, many listed in the *American Stock Journal* and the *American Short-Horn Herd Book.*

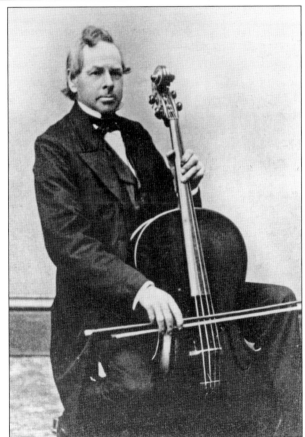

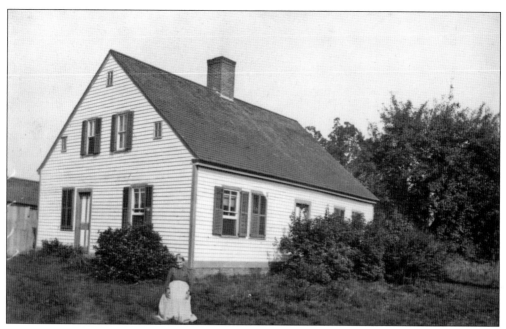

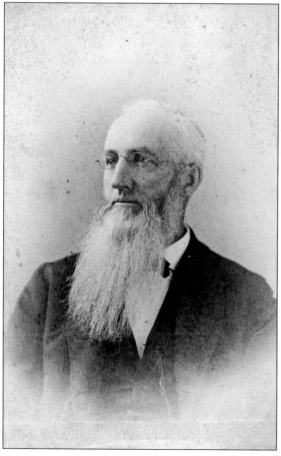

Tarbox Tavern. Frank Tarbox built this house in 1802 to serve as a tavern on the stagecoach route. The First Congregational Church purchased it and four acres of land from Mary Bartlett in 1925 as a residence for the janitor of the church. In 1945, the church remodeled it, and Rev. Virbrook Nutter used it as a parsonage. He also took over the janitorial duties. It sits today just north of the church.

Sereno Watson, PhD. This distinguished botanist, explorer, and author was born in 1826 in East Windsor Hill, then part of East Windsor, and graduated from Yale in 1847. For a short time, he taught at the Scantic Academy. Later, he joined the US Geological Survey's 40th Parallel Survey Expedition as its botanist and published many respected works. In 1873, Harvard University appointed him curator of its herbarium and botanical garden, a position he maintained until his death in 1892.

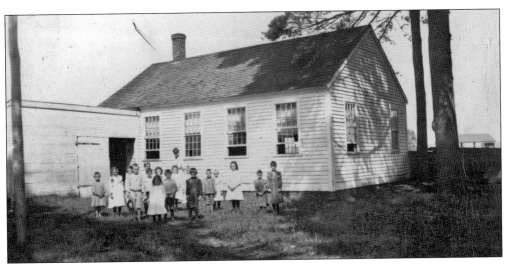

THE LITTLE WHITE SCHOOL HOUSE. By 1850, the town operated 12 public school districts. This original schoolhouse in District 1 was built in 1830 on Cemetery Road, but was moved twice before landing on Scantic Road near the academy. Instead of a fireplace, a large stove was placed to warm the children at their red desks and curved-back chairs. During the 1938 hurricane, a large pine crashed through its roof, closing the school.

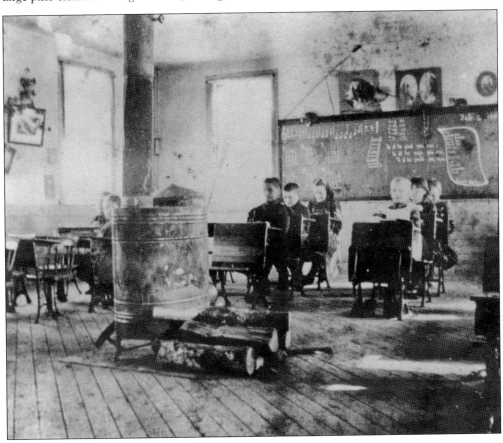

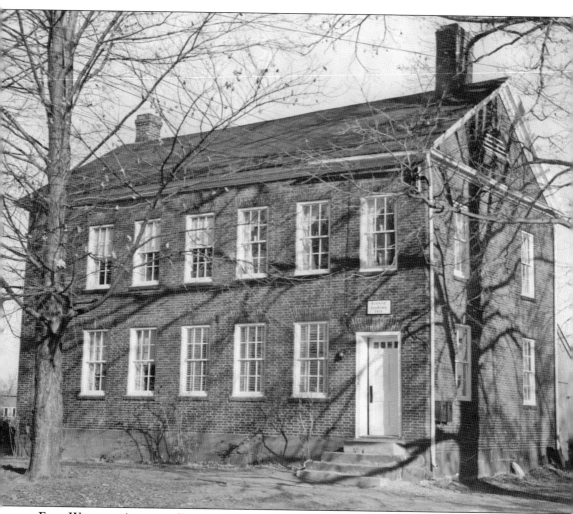

East Windsor Academy (Scantic Academy). Now the home of the East Windsor Historical Society, the Scantic Academy was built in 1817 for the Ecclesiastical Society as an institute for higher learning by a committee of three stockholders: Israel Allen, Stephen Potwine, and Samuel Bartlett Jr. Located on Scantic Road near the First Congregational Church, it offered young students higher English and classical studies. Students from Yale College were usually employed as teachers. Notables such as Junius S. Morgan, father of J. Pierpont Morgan, and Yung Wing, a well-known Chinese traveler of the time, attended. After its school years, this building served in many capacities, such as hosting exhibitions and caucuses, a singing school, social and political reform discussions, debates, and a grange, to name a few. It was sold in 1946 to L. Ellsworth Stoughton, who converted it into two apartments for area teachers. In 1965, he founded the East Windsor Historical Society and converted the second floor into a museum. He bequeathed the entire property to the historical society after his death in 1991.

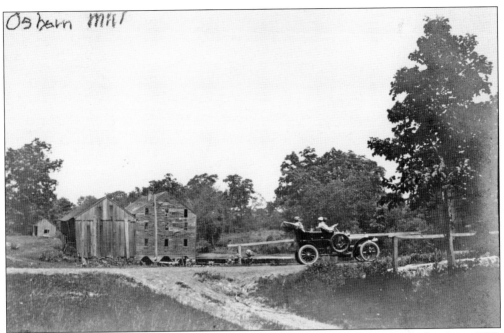

Osborn Mill

THE OSBORN MILL. The sawmill, no longer standing, was built by the Harper family in 1728. It was purchased by Daniel Osborn in 1782, and the Osborn family operated it until the early 1900s. Located upstream from the Woolam and Omelia Roads junction, they produced lumber for building, ground limestone for plaster, and ground grain for feed (with the surplus being used by the local gin distilleries). Wool was combed and carded in the loft.

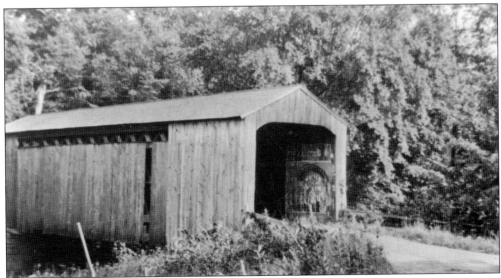

FIRST COVERED BRIDGE. The first bridge, and the only covered bridge, in East Windsor spanned the Scantic River at the junction of Woolam and Omelia Roads just downstream from the Osborn Mill. It was built in 1842 using the Towne triangle truss system. The population no longer had to ford the river by horse and buggy, rowboat, or on foot. It was replaced by a modern bridge in 1928.

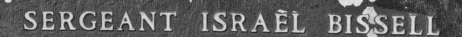

SERGEANT ISRAËL BISSELL

Born in East Windsor, Conn. 1752.
Carried the "Lexington Alarm" to
Philadelphia, 350 miles on horseback
in five days from Watertown, Mass.
After the war was over he moved to
Middlefield and later Hinsdale, Mass.,
where he died and was buried in 1823.

ERECTED IN 1973 BY
THE JOHN BISSELL 1628 ASSOCIATION

ISRAEL BISSELL. Born in East Windsor in 1752, Bissell was a patriot post rider who brought news to the American colonists of the British attack on April 19, 1775, in Lexington, Massachusetts. He rode from Watertown, Massachusetts, to Philadelphia carrying the message:

> To all the friends of American liberty be it known that this morning before break of day, a brigade, consisting of about 1,000 to 1,200 men landed at Phip's Farm at Cambridge and marched to Lexington, where they found a company of our colony militia in arms, upon whom they fired without any provocation and killed six men and wounded four others. By the express from Boston, we find another brigade are now upon their march from Boston supposed to be about 1,000.

The message also stated that Bissell was charged to alarm the country "quite to Connecticut," and requested that he be furnished with fresh horses as needed. It was signed by J. Palmer of the committee of safety.

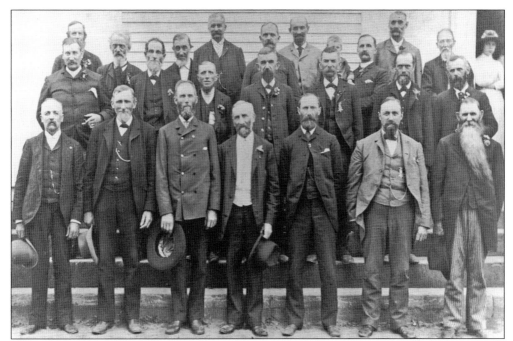

CIVIL WAR REUNION. From April 1861 until May 1865, America was at war. Each town had a quota. The town of East Windsor took part in the bounty system, whereby each militiaman was paid a sum of money to join. In 1862, it was $100 for three years. In 1863, the sum was upped to $300. Here, men from Company G, 25th Regiment, pose on the steps of the Scantic church during a reunion.

MAJOR BARTLETT HOUSE. The main house was built in 1830 on the corner of Scantic and Cemetery Roads, but the original kitchen was built before 1752. Maj. Samuel W. Bartlett lived here with his family. He is listed as a member of the 25th Regiment Infantry of the militia in the *Connecticut Annual Register* for 1837. It is reported that he also played in the drum corps during the Civil War.

S. Terry Wells Farm. This home still stands where Mahoney Road dead-ends at Wells Road. The original structure can still be detected among the many additions made since Terry Wells's father, Solomon, built it in 1830. This farm is an excellent example of family farming. Terry Wells wrote in his diary for July and August 1890: "carted loads of hay clearing the east lot, lots of days of haying, lots of calfing also and selling calfs, bred Hoderness cow with Potwines bull, bought a load of coal from BB Clark, worked on road in front of house, interviewed school teacher, wife and Herbert sold hens in Hartford 12 cents a pound, sold potatoes at BB for 50 cents a bushel, sow had 6 piglets, attended Farmers Club, commenced to cut tobacco & hang tobacco." Terry was also a selectman and took an active role in the Grange and Scantic Church. The early settlers of East Windsor were strong, hardy, and resourceful.

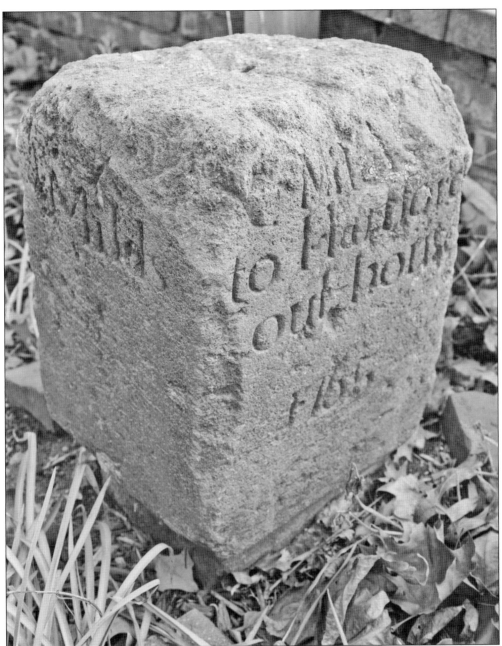

POST ROAD MILESTONE. Benjamin Franklin was appointed deputy postmaster in America in 1737 and postmaster general for the Colonies in 1753 by the English crown. He held this office until the king dismissed him on January 30, 1774. The first posts were carried on horseback, but after roads improved, stagecoaches became the mode of delivery. When he was first appointed, Franklin ordered postal markers be laid to establish distances from major post offices. East Windsor's stone stood in a field near Stoughton Road on Route 5 for 202 years. The marker reads: "X Mild to the Hartford Cout Hof 1765" (10 Miles to the Hartford Court House). It is one of only two Connecticut markers that bear a date. In 1967, with the help of the State Highway Department, the marker was moved to the grounds of the historical society on Scantic Road for safe keeping.

L. ELLSWORTH STOUGHTON, MR. EAST WINDSOR. It is doubtful that anyone knew or loved East Windsor more than Ellsworth Stoughton. A direct descendant of the earliest settlers of Windsor and East Windsor, he grew up on one of the oldest roads in the state and founded the East Windsor Historical Society. Ellsworth was a relentless pursuer of information, documents, and artifacts relating to the town, donating it all to the historical society, including the 1817 Scantic Academy building. He was a farmer, deliverer of livestock feed, town official, world traveler, and church official. Until he reached his 80s, he regularly climbed the long ladder to the steeple of the First Congregational Church to reset the antique clock weights. Born in 1898, he had hoped to live for 102 years, not for the longevity but for living in three centuries, as had one or two of his ancestors. Ellsworth died in 1991.

Three

THE VILLAGE OF
BROAD BROOK

In the latter 1700s and early 1800s, settlers from the southern and western areas of East Windsor began to migrate northward and eastward to the area now known as Broad Brook. In 1815, the area consisted of five houses with a population of 40. The primary land use was farming, with major crops of tobacco, potatoes, and rye. The village also had a gristmill, sawmill, shoemaker, wagon maker, tannery, and blacksmith.

In 1835, Epaphras and Bethual Phelps purchased waterpower rights and sites, land, and buildings. Using native red sandstone mined from a quarry under the Main Street bridge in the center of the village, they constructed the first mill building along the brook. By 1850, due to the demand for cashmere and worsted wool manufactured at the mill, the village grew to approximately 50 homes with a population of more than 300. Many of these houses were built and owned by the mill and rented to its employees. Like many mill towns in America, the village grew around the mill, which became paternalistic towards its employees. For the next 113 years, the mill was the main economic entity of the village and gave employment to hundreds of people until closing in December 1953.

During the operational years of the mill, many businesses were established supporting the center, making it a self-sustaining village. The business community consisted of barbershops, a brick yard, a button factory, dance halls, doctors' and dentists' offices, drug and dry good stores, gasoline service stations, general stores, grocery and meat markets, hardware stores, hotels, ice cream parlors, taverns, a post office, and churches. Within a decade after the closing, many of the businesses that lined the streets around the mill closed and moved away.

In 1965, Hamilton Standard Division of United Technologies purchased the mill property, and for 15 years, an electronics manufacturing department was located in the main structure. In 1986, John Cotter, an East Hartford–based developer, brought new hope for the village when he purchased the century-old complex to renovate it into residential and commercial space. Unfortunately, while the work was being performed, an era came to an end. On May 22, 1986, the mill was destroyed by fire. Although the glory days of the village are over, Broad Brook still remains a viable part of the town of East Windsor.

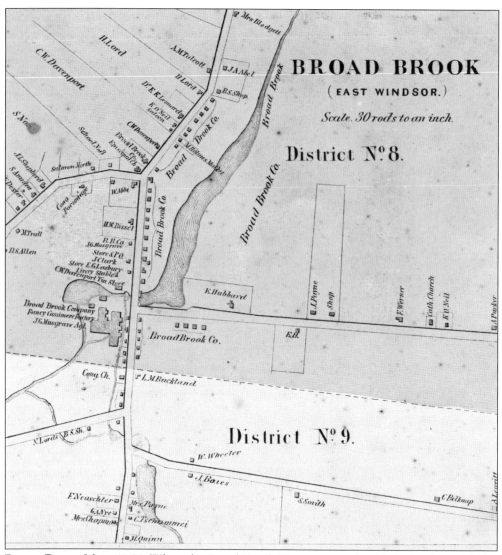

BROAD BROOK MAP, 1869. When the Broad Brook Company purchased the bankrupt Phelps Company in 1849, it built commercial buildings and housing for its employees' use. This map shows the breadth of the mill's holdings in town in 1869. About 1935, it sold the houses to the workers occupying them and tore down older homes. By its closing in 1953, all buildings were out of its hands.

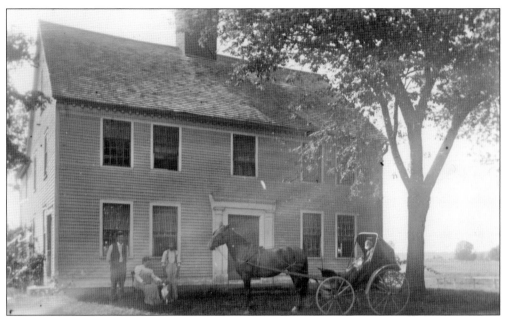

SOLOMON ELLSWORTH HOUSE AND DINOSAUR FIND. Lt. Solomon Ellsworth was born in 1737 and built this early Connecticut valley center-chimney Colonial home on Rye Street about 1756. Serving in the Revolutionary War as a lieutenant in Capt. Lemuel Stoughton's company in the East Windsor militia, he marched on the Lexington alarm on April 19, 1775. While blasting for a well in 1818, Solomon Ellsworth Jr. found the first dinosaur bones in North and South America for which the site, the bones, and the documentation still exist. Documented in 1988 by Dr. John Ostrom from the Peabody Museum and Signey S. Quarrier, state geologist, the bones reside at the Peabody Museum in New Haven, Connecticut. They are from an Anchisaurus, a dinosaur from the Jurassic period, 188 to 200 million years ago. (Above, courtesy of Ron and Nancy Masters.)

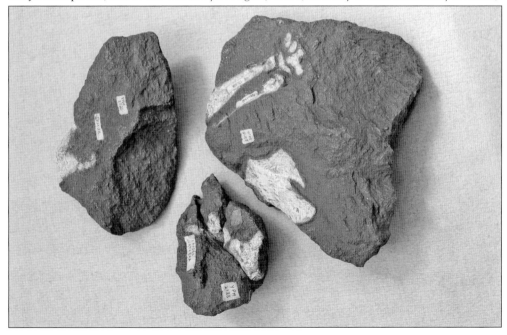

JABEZ S. ALLEN HOUSE. Jabez Allen's ancestors came from England and found their way to East Windsor in the mid-1600s. The Allen clan built homes along North Road and Melrose Road crossing the Scantic River and into Melrose; the area became known as the Allen District. Jabez's home (first occupied by his father) stood at the southwest corner of Yosky and Melrose Roads until 1960, when it was dismantled and used to renovate a saltbox house at East Windsor Hill. Besides regular farm work, he raised thoroughbred Durham cattle and was a state representative in 1854, 1870, and 1871. He and his father, also named Jabez, were very active in the Scantic Congregational Church, teaching music and directing the choir. In his 1856 diary, he talks of teaching 16 Germans in Broad Brook to "start a brass band" (the Liedertafel Society). Sitting in front of the house in 1937 is Albina Yosky Kalmer, whose father, Michael Yosky, purchased the farm to raise tobacco in the 1920s. (Courtesy of Patricia Donahue.)

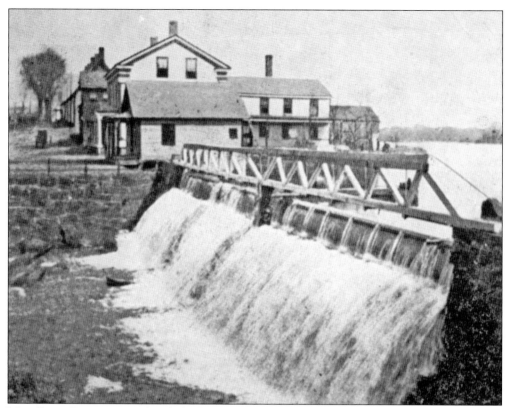

MILL POND DAM, 1849. The Phelps brothers purchased the dam area known as Blodgett's Falls in 1835. A dam was built, and the water was used to rotate the turbine that was the power source for the mill. The water was channeled through a flume to the turbine, located at the southern end of the mill. Retaining walls were built with native red sandstone from the quarry under the Main Street bridge. (Above, courtesy of At the Dam Restaurant.)

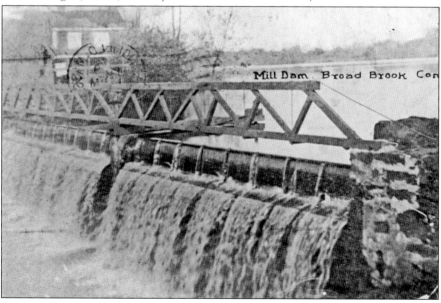

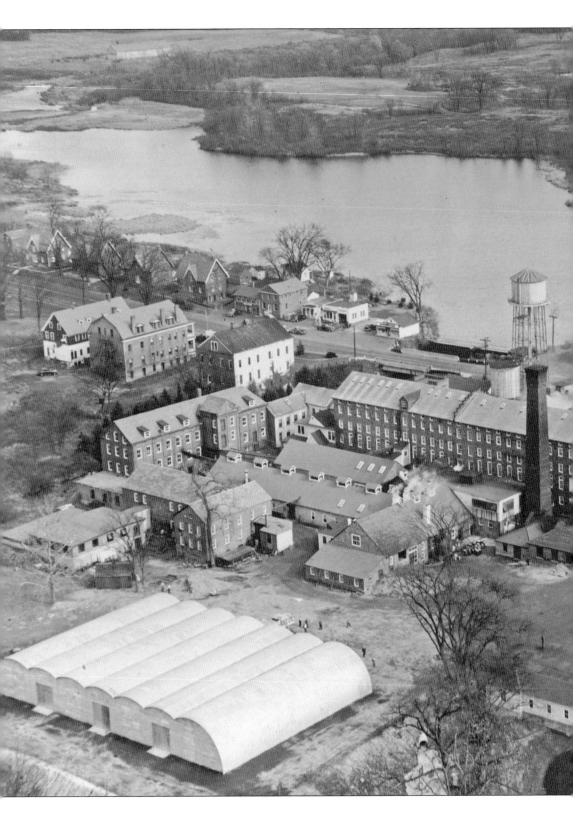

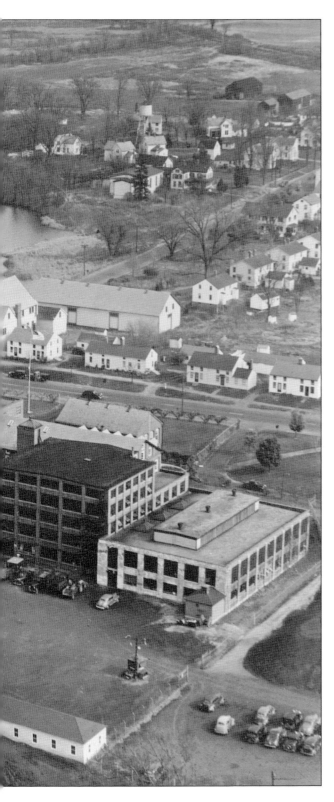

BROAD BROOK COMPANY, 1947.
Shown is the center of the village
of Broad Brook with the mill
as the hub of the community
and business life. Built of native
red sandstone mined from the
quarry under the Main Street
bridge, it was first known as the
Phelps Manufacturing Company,
producing wool cloth. The Phelps
mill went bankrupt in 1849 and
the Broad Brook Company came
into existence. It was noted for
high-grade cashmere and woolens.
During the Civil War and World
Wars I and II, wool blankets and
military cloth were manufactured,
and later the mill made upholstery
for General Motors automobiles.
Shops, hotels, churches, grocery
stores, meat markets, barbers, and
banks are a few of the businesses
shown lining both sides of Main
Street. This business district,
operated by residents who filled a
need for the growing community,
made for a thriving village.

55

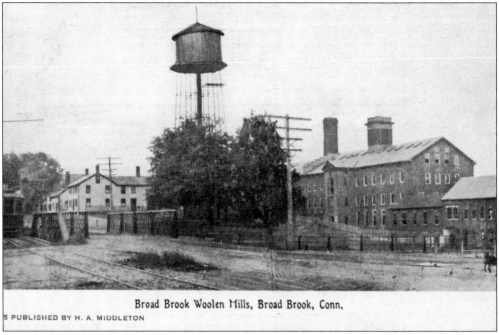

Broad Brook Woolen Mills, Broad Brook, Conn.
5 PUBLISHED BY H. A. MIDDLETON

BROAD BROOK MILL. This view of the mill in the early 1900s shows the trolley tracks on Main Street. The company houses on the left were demolished in 1938 and the 1940s to make room for an updated security fence.

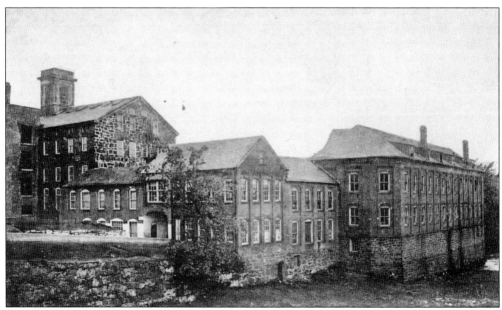

BROAD BROOK MILL, SIDE VIEW. In this view of the mill from the Mill Pond bridge, note the damage to the foundation and walls by the flooding of the Broad Brook Stream over the years.

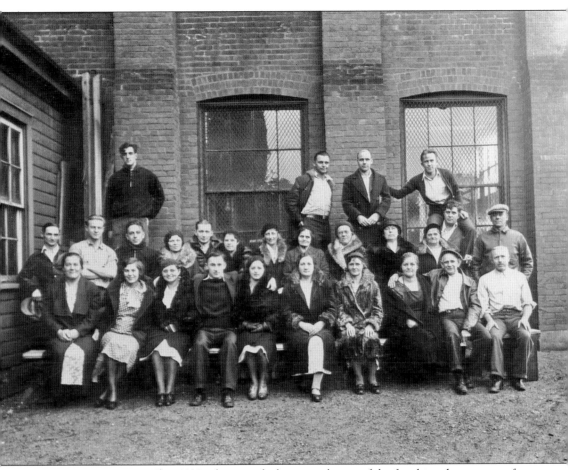

FINISHING DEPARTMENT. This 1930s photograph shows employees of the finishing department of the Broad Brook Company. This department performed many operations in the manufacturing process. When a cut of cloth, approximately 100 yards, was sent to the burling room, knots and foreign material were removed from the cloth using a small pair of scissors and a burling iron. A burling iron is a type of tweezers about three inches long and half an inch wide, tapered to a point. The workers were paid by the number of yards of cloth they processed. The cloth was then sent to the sewing room, where missing threads or picks were sewn back in. From left to right are (first row) Annie Vozek, Genevieve Vozek, Alma Rice, John Shary, Ester Ungerwitter, Josephine Dorman, ? Ziolo, ? Kristofak, unidentified, and ? Olesek; (second row) ? Olesek, Charles Donahue, Harry Quist, Gertrude Stolle, John Butenus, Mary Staiger, Margarte Cates, Anna Dublinski, Mary Miller, Katherine Kubasek, Mary Polinik, Charles Koetch, and Adam Eaglevitch; (third row) James Hall Jr., Joseph Wysocki, William Sheets, and unidentified. (Courtesy of the Donahue family.)

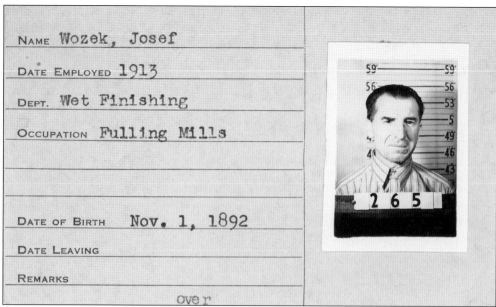

PERSONNEL CARD. Many immigrants arrived in Broad Brook for the job opportunity and stayed to raise a family. This is a typical Broad Brook Company employee card. Joseph Wozek arrived in America from Poland at the age of 22 in August 1911 aboard the SS *Finland*. He was hired in 1913 and worked in the wet finishing department. He received his 40-year service award in 1953. (Courtesy of the Donahue family.)

MILL ROSES. The village came alive with roses during the summer months. In the late 1930s or early 1940s, the mill owners installed a chain-link fence and planted climbing red roses along the front section, adding beautiful foliage and blooms of color along Main Street. Benjamin Hensel tended the roses. They were still in existence in the early 1960s.

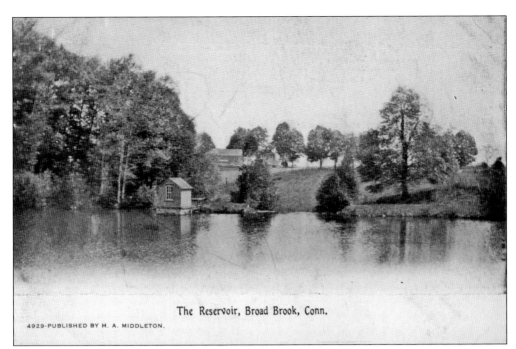

The Reservoir, Broad Brook, Conn.

4929-PUBLISHED BY H. A. MIDDLETON.

THE RESERVOIR. In 1892, the Broad Brook Company purchased land off Highland Avenue to construct a dam on Chestnut Brook to create a reservoir. A 12-inch pipe line was installed from the reservoir to the mill yard to provide a sprinkler system for the mill and fire hydrants for the center of the village. Today, the reservoir in the East Windsor Park provides recreation for the community. (Courtesy of Linda Brewer.)

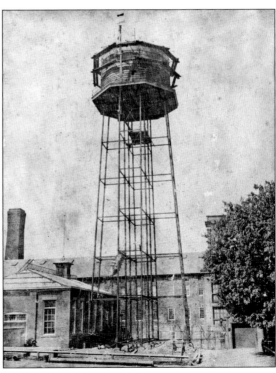

MILL WATER TANK. The manufacturing process demanded water for power. The mill utilized water from the Mill Pond, Butternut Pond, and the reservoir to run its machinery. In 1904, it was determined that the water pressure was too low to maintain the sprinkler system on the upper floors. An 80-foot high, 50,000-gallon wooden water tank was built to solve this issue. The opera house, dye house, repair shop, and coal storage houses also benefited from this water source.

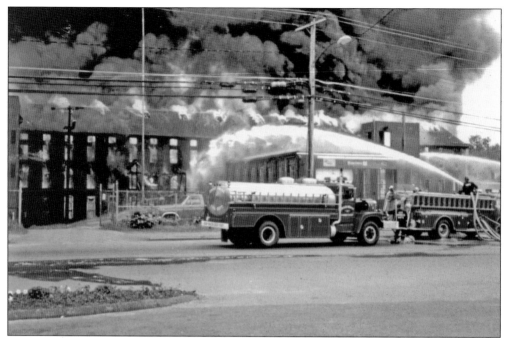

MILL FIRE. Planning to renovate the mill into residential and commercial space, John Cotter, an East Hartford developer, purchased the old Broad Brook Mill complex in January 1986. With the approval of the East Windsor Planning and Zoning Commission, he started work on the first phase of the project. On May 22, 1986, a fire ended the renovation plans for this historic mill complex. The blaze apparently began when a worker cut a heating pipe, creating sparks that caused an explosion and fire. The flames spread quickly across the oil-soaked floor and were fanned by gusty winds. Ten fire departments responded with 27 fire apparatus and about 200 firefighters, mostly volunteers. Fortunately, there were no serious injuries.

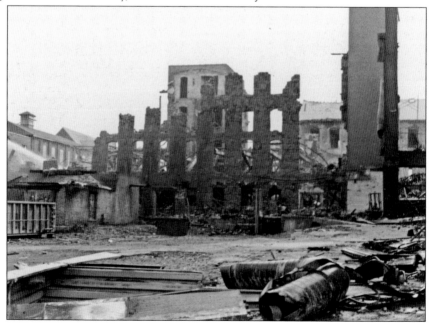

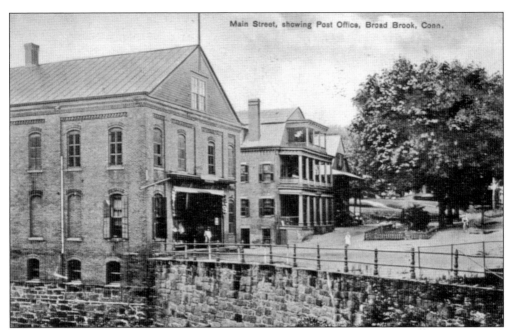

E.W. PIDGEON DRUG STORE. The Broad Brook Company built this structure in the early 1800s at the edge of the Broad Brook Stream. The store was operated by Edward O'Connell until about 1915, when Ernest Pidgeon purchased the business. In 1900, the post office was relocated here from the basement area of the Broad Brook Hotel. The retaining wall in the foreground was built with native red sandstone mined from the stream area. (Courtesy of Keith Cotton.)

THE BROAD BROOK HOTEL. Constructed in 1840, it was also known as the Hubbard Hotel after its first proprietor. The top two floors had sleeping and dining accommodations for travelers. The third floor was an auditorium where vaudeville groups practiced prior to performances in New Haven and New York City. The basement area was occupied by a barroom, the central area by the post office, and the rear by a harness shop.

61

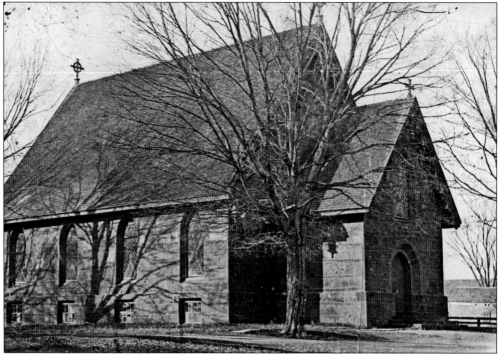

GRACE EPISCOPAL CHURCH. A group of citizens including Bethuel Phelps, founder of the mill, wanted to establish a congregation in Broad Brook. By 1845, they raised $3,000 for a building. The church was built on the corner of Main and Church Streets and, like the mill, was constructed with native red sandstone mined from the quarry under the Main Street bridge. It served as a parish from 1847 until 1961, when it was deemed unfit for occupancy. It was demolished in 1962. During its 115 years of existence, the roof was blown off at least three times, twice from strong winds and rain in 1922 and 1925 and the third time during the 1938 hurricane. A new Grace Episcopal Church was built on the corner of Old Ellington and Norton Roads and dedicated on September 30, 1964.

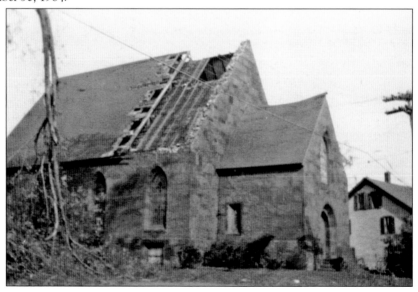

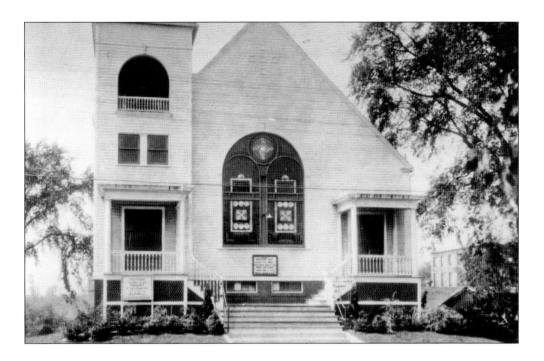

BROAD BROOK CONGREGATIONAL CHURCH. Before 1851, Congregationalists in the village attended the First Congregational Church in Scantic. Deciding they wanted a church closer to Broad Brook, they held services at the District No. 9 schoolhouse on Rye Street, later owned by St. Catherine Church, and then on the top floor of a mill building, later Pidgeon's Drug Store. Finally, in 1854, a proper structure was built in the center of the village. The Rev. Shubael Bartlett, pastor of the First Congregational Church, officiated at the dedication. When a fire caused by an overheated furnace destroyed the building in 1893, the parishioners immediately replaced it with this late-19th-century Romanesque Revival building. Below, parishioners gather on the steps to celebrate the 80th anniversary in 1931.

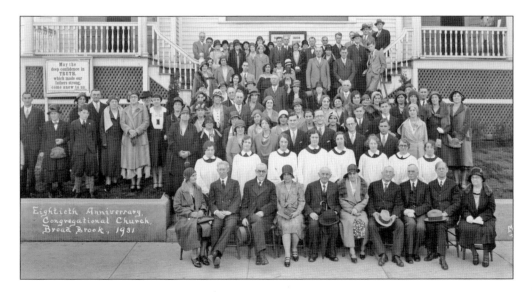

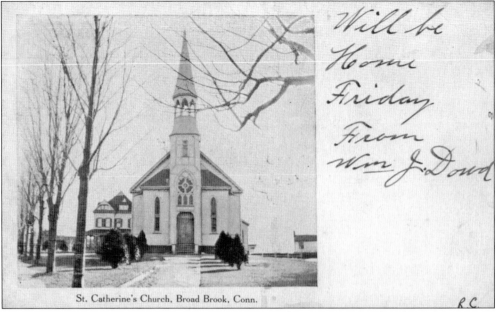

St. Catherine's Church, Broad Brook, Conn.

Will be Home Friday From Wm J. Dowd

ST. CATHERINE CHURCH. The parish was first formed as St. Patrick Church, and in 1862, a building was constructed at 75 Depot Street on land donated by Elihu Hubbard. The present church was built in 1881 on land donated by Kieron O'Neil. The parish was officially created as St. Catherine Parish in 1886. It is an excellent example of a 19th-century Gothic Revival church with its Gothic tracery stained glass. (Courtesy of Keith Cotton.)

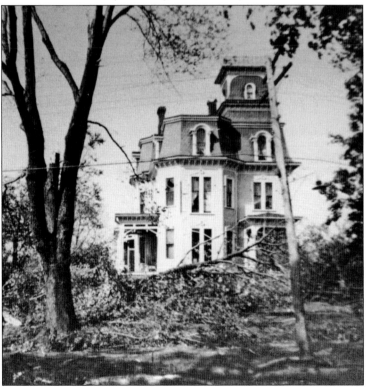

THE MANOR HOUSE. The large Victorian house on Main Street was built by the Broad Brook Company in 1870 for the company's general manager, Alexander Semple. It was graced with a long circular driveway, many trees, and a manicured lawn. During the 1920s and 1930s, the Liedertafel Brass Band held concerts on the lawn. Later, it became a privately owned boardinghouse with a bar and dining facilities named the Brookside Manor. As seen here, trees were uprooted during the 1938 hurricane.

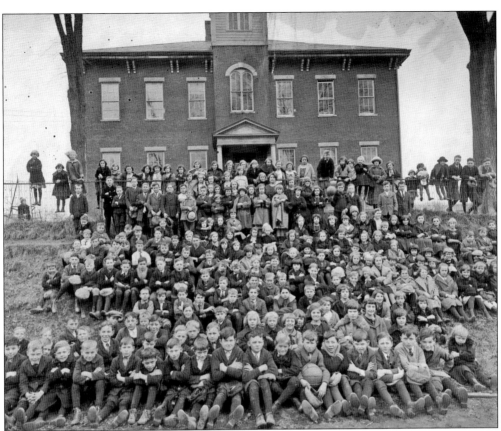

BROAD BROOK GRAMMAR SCHOOL, 1874. During the 1800s, there were 12 school districts in East Windsor. By 1873, it was time to consolidate. The village of Warehouse Point voted to keep its district separate from Broad Brook and built its own school. In Broad Brook, land was purchased on the east side of Main Street from J.F. Mann. A brick two-and-a-half story, eight-room building with a bell tower was erected. For 77 years, hundreds of children spent their days learning, playing, and growing up here, until 1952, when a new, modern school opened on Rye Street to meet the needs of a growing population. Thereafter, the East Windsor Town Hall occupied the space. A spectacular fire fought in sub-zero weather destroyed this historical icon on January 24, 1961.

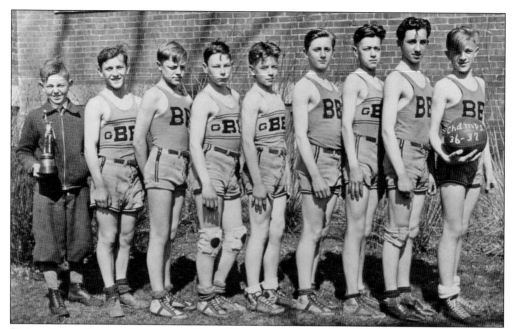

BROAD BROOK SCHOOL BASKETBALL TEAM. These sixth-, seventh-, and eighth-graders are standing proudly after winning a trophy in 1937. From left to right are Thomas Pitney (manager), Edward Grigely, Stanley Krupienski, John Pease, William Neelans, William Ziolo, Francis Muska, Joseph Racz, and Martin Heubner. Until 1951, all grammar school home games were played on the second floor of the opera house.

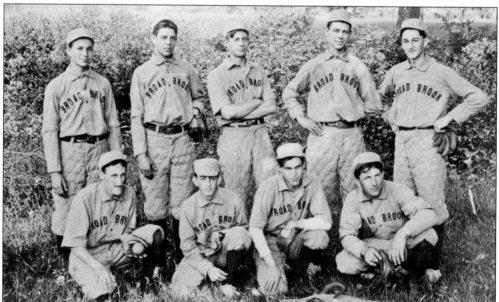

BROAD BROOK BASEBALL TEAM, 1905. Everyone enjoys the national pastime. Shown is one of Broad Brook's earliest baseball teams. From left to right are (first row) John Sinniwald, William Gayton, Raymond Arnold, and Paul Rostek; (second row) Frank Goettler, Louis Otto, Herman Otto, William Otto, and Sidney Gayton. There were several fields about town. One location was Tank Alley, on Depot Street at the site of the Broad Brook Company water tank.

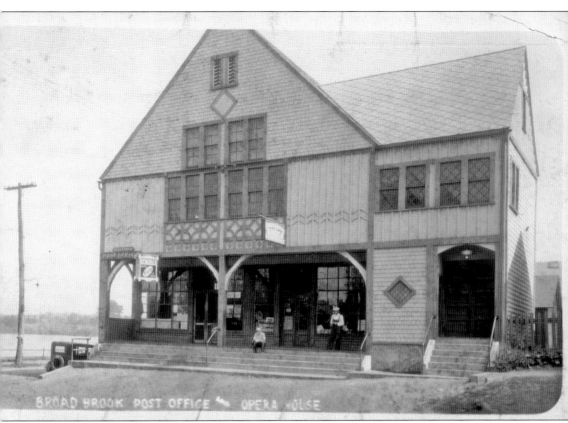

BROAD BROOK POST OFFICE & OPERA HOUSE

THE OPERA HOUSE. The Broad Brook Company erected this Queen Anne–style building in 1892 as a salesroom for company products in the front area and the shipping department in the rear. The top floor served as a hall and was the social center of the community, with everything from dances, basketball games, minstrel shows, and school graduations to homecoming events for the servicemen and -women. In 1920, the company relocated the departments back to the main mill complex, and Tyler's Pharmacy and Ice Cream Parlor, the post office, and Sargent's Shoe Store then took occupancy on the first floor. The opera house is an excellent example of the benevolence of industries like the Broad Brook Company that dominated small towns in New England in the 19th century.

HARRY HOUDINI. During the Great Depression of the 1930s, Harry Houdini, the famous magician, performed his magic act on the stage at the opera house for 10¢ per ticket. Before the performance, he was blindfolded and drove an automobile through town. Later, questions were asked regarding the opaqueness of the blindfold, because a truck was deliberately driven in front of Houdini's car and he came to a screeching halt. He is pictured entering the Broad Brook Hotel parking lot.

THE OLD SWIMMING HOLE. In the 1930s, areas of the Scantic River were used for swimming. The one pictured here was known as the "trestle" and was located at the bend in the river just west of the intersection of Mill and Church Streets. Since they swam in the nude, only men frequented this site, making sure to hide in the water when a trolley car approached. (Courtesy of the Donahue family.)

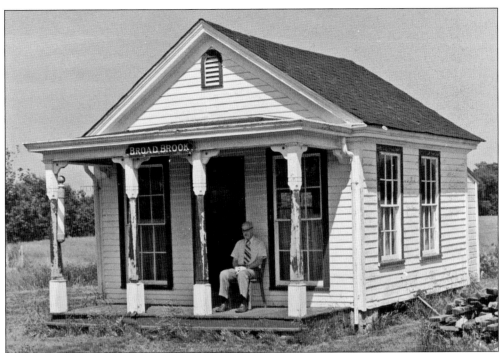

FOUR BARBERS, ONE SHOP. Max Ertel, at age 22 in 1884, bought Bernard Carney's barber business, which was housed in the Middleton Store on Main Street. After eight years, the Broad Brook Company erected a new building for Ertel. Here he worked until 1919, when he sold the business to Judge Ruldolph Geissler. In addition to being a barber, Geissler was also the municipal judge. In 1953, after 43 years, he retired and sold to John Butenus, who learned to barber from Geissler at age 16 and worked until age 73. One of the oldest barbershops in the state, the building is now preserved and on display on the grounds of the East Windsor Historical Society in Scantic. Above, L. Ellsworth Stoughton sits on the porch. Below, in 1953, John Butenus waits on his last customer, Edward McCullough.

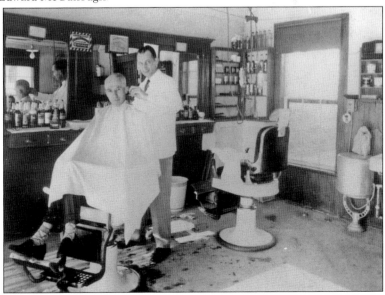

MAX ERTEL. America is a nation of immigrants who came for a better life, and many found that life in Broad Brook. Max Ertel was one. He arrived in America at the age of 19, a full-fledged barber with four years of apprenticeship and a book of translation. Coming from Saxony, Germany, in 1881 by way of New York City aboard the steamship *Nektar*, he worked a year in a cotton factory and a year as a barber in Rockville. Ertel mastered the English language through self-instruction and close attention to the conversations going on around him. In 1884, when he was only 22, he purchased a barber business in Broad Brook, running it until 1919. He married Ida Helm, a native of Broad Brook, in 1887, and together they raised nine children. Through his efforts, he attained the American dream.

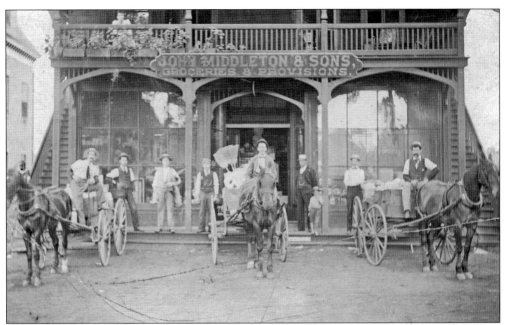

MIDDLETON STORE AND MARKET WAGON. This building at 96 Main Street was built in 1885 by the Broad Brook Company and housed the John Middleton & Sons Groceries & Provisions store on the first floor. Two apartments were on the upper floors. The 1890 photograph above shows John Middleton standing to the right of the door. He was a member of the State General Assembly in 1883–1884 and 1895. Following his political lead, his son Howard Allen Middleton became the Republican senator for the Seventh District. In the 1930s, the A.H. Phillips Grocery Store occupied the store area. The photograph below shows how goods were transported during the time that Middleton's store was in operation. The store closed in the spring of 1907.

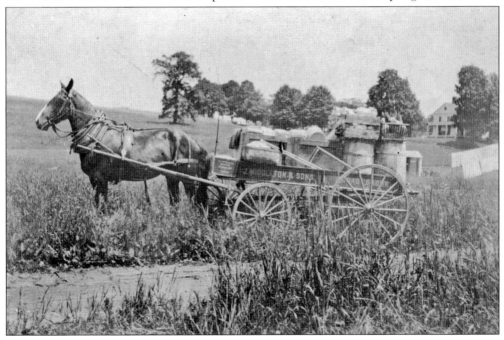

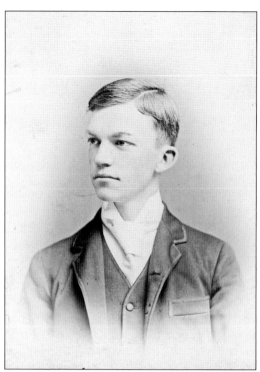

Hon. Howard A. Middleton. After attending Hartford Public High School, having traveled by train from Melrose, Howard Middleton joined his father at the John Middleton & Sons Store. He became the Republican senator and delegate from East Windsor to the Constitutional Convention of 1902. In remembrance of the convention, each delegate received a pin oak tree to plant in his town. Howard Middleton planted the Constitutional Oak at the Scantic Congregational Church. In 1965, the tree died and was replaced with a marker.

Reid's Market, 1910. This market was located on Depot Street opposite Tank Alley. From left to right are William Helbig, Frank Wheeler, Frank Kirchhof, unidentified, and Pat Reid in front of the People's Meat Market, which was owned and operated by Patrick Reid.

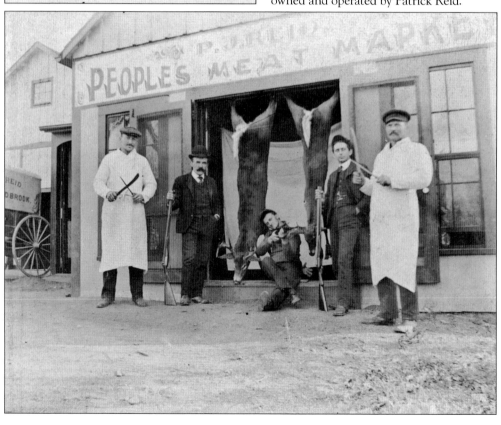

PEARLVILLE. In 1851, a half-mile east of Broad Brook center on Depot Street, Andrew Hamilton owned a pearl button factory using the mother-of-pearl from oysters like the ones pictured. After a fire destroyed the original building in 1854, Hamilton formed a rifle manufacturing company. Unsuccessful with that, he returned to pearl buttons with several different partners. In 1863, he formed A. Hamilton and Company with new partners, and the business became profitable. Other items made included pearl tooth powder, polishing powder, tin buttons, vegetable ivory buttons, metal ornaments, pearl jewelry, and finger rings. After another fire destroyed the buildings in July 1870, Hamilton rebuilt and manufactured typewriter ribbons and carbon paper. When fire again leveled the buildings in 1877, he gave up and became a farmer.

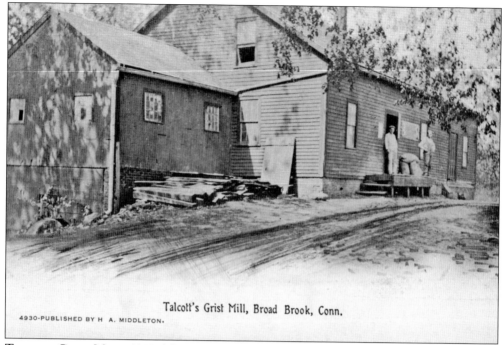

Talcott's Grist Mill, Broad Brook, Conn.

4930-PUBLISHED BY H A. MIDDLETON.

TALCOTT GRIST MILL, 1910. Many towns within the Connecticut River valley had mills as far back as the 1600s. Broad Brook was no different. The Phelps brothers (woolen mill owners) purchased this mill to procure the water rights and sold the mill to let it continue as a gristmill. Originally Bissell's Mill, Talcott Grist Mill was located on Mill Street in Broad Brook just east of Stiles Road.

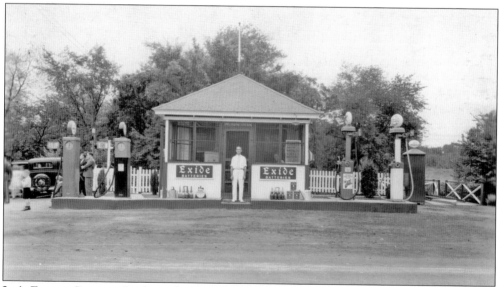

JIM'S FILLING STATION. In the early 1920s, James Loftus operated this repair and filling station on Mill Street alongside the Chestnut Brook. The brand names of the gasolines were Lydol and Vedol. During the summer, the Broad Brook Fife and Drum Corps held practice sessions in a park area Loftus maintained next to the building. Men also gathered here to pitch horseshoes. There is a multifamily home at this location now.

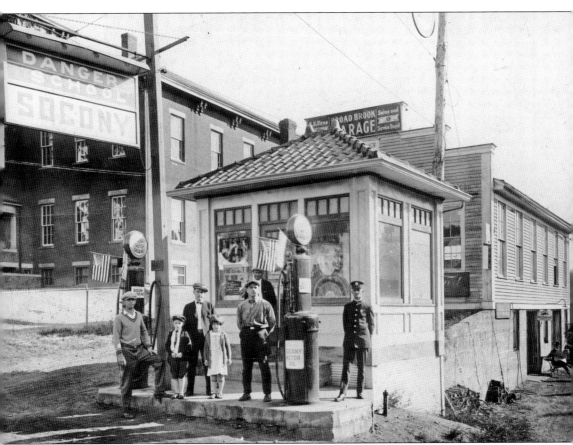

BROAD BROOK GARAGE, 1925. These two buildings, built in 1918, are significant because they are well-preserved examples of early-20th-century gas station architecture. The smaller one near the road, with its gas pumps and iconic red tiled roof, still stands today in the center of the village as a historical reminder of bygone village life. Frank Kirchhof operated a Buick dealership and a farm equipment sales and repair service here. In the early 1930s, he sold the business to George Sargent, who operated a Chevrolet dealership. In the 1940s, Wilfred Sweeney purchased it and operated an auto repair service, also selling new and used cars. Villagers pictured are, from left to right, Bill Seiber, Ernest Artz, Max Artz, Viola Artz, Adolph Heuhner, and Frank Kirchhof (in uniform). Standing in back under the flag is Harry Schlude. The Broad Brook Grammar School, which burned down in 1961, is on the left.

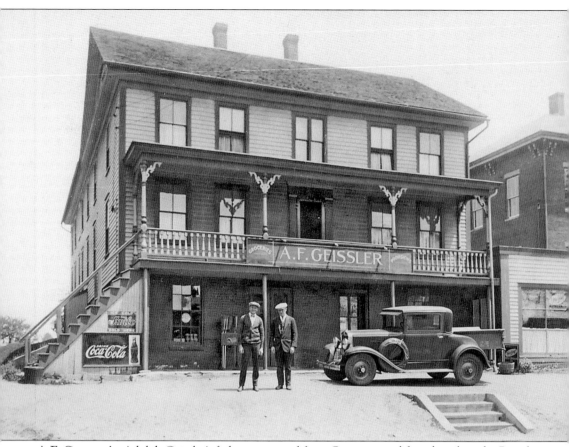

A.F. Geissler's. Adolph Geissler's father emigrated from Germany and found work at the Broad Brook Company. Buying the house at 123 Main Street, he raised a sizable family. Adolph was the 11th of 12 siblings. His younger brother opened a grocery and provisions store on the first floor, and in 1923, Adolph purchased it. During the early years, when automobiles were scarce, people depended on home delivery. Adolph Geissler would ride around town in a Model T Roadster collecting orders, then ride back again to deliver them. The store prospered, and in 1949, he bought a second store in the Warehouse Point section. In 2016, Geissler's Supermarket had seven locations throughout Connecticut and Massachusetts. Geissler's daughter and son-in-law, Mary and James Nilsson, and their family continue his legacy. Geissler's Supermarket undoubtedly became a Broad Brook success story. The building itself has a history as an incubator for businesses. Chester's Market and Paul's Package Store also had their start here before moving on to larger, more modern sites. (Courtesy of Jim Nilsson, Geissler's Supermarkets.)

HALL AND MUSKA GASOLINE STATION, 1940. A boardinghouse owned by the Broad Brook Company occupied this property until 1938, when it was razed to make room for this gasoline and service station. The station's oil storage tanks were located on Mill Street. The tanks were dismantled and the station demolished in the 1960s, after the headquarters of the Hall and Muska Oil business relocated to Route 191 near the East Windsor–Enfield town line. Below, Tillie Corrodi is standing in front of the service station in 1940. On the right in the background is Geissler's Barber Shop, now located at the East Windsor Historical Society.

BROAD BROOK LIBRARY. Although the library association existed from 1919, it did not have a building to call its own and was housed in several places throughout the years. In 1955, the Broad Brook Company donated $5,000 to purchase this 100-year-old brick house on the corner of Church and Main Streets. Standing at the door are Mr. and Mrs. H. Wesley Sargent.

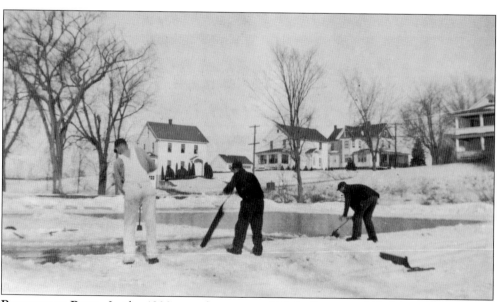

BUTTERNUT POND. In the 1800s, on the corner of Main Street and Highland Avenue, the Butternut Pond was a source of power. Named for the butternut trees that surrounded the pond, it came into existence with the damming of Chestnut Brook. About 1935, Frank Kirchhof built a tavern. Here, men are harvesting ice to be used to cool the beer. After the 1955 flood damaged the dam, it deteriorated and was never repaired or replaced.

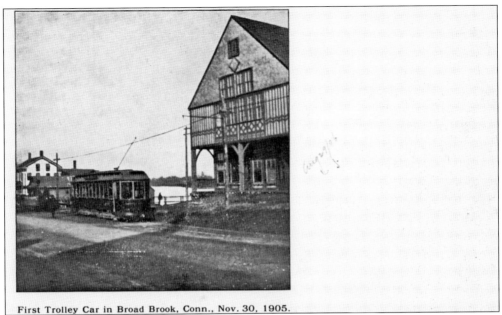

First Trolley Car in Broad Brook, Conn., Nov. 30, 1905.

BROAD BROOK TROLLEY. The trolley line to Broad Brook opened for business on November 30, 1905. A traveler could board the trolley at Boleyn's Corner in Warehouse Point, ride through Scantic (Station 9), cross the Scantic River at the Church and Mill Streets intersection, proceed up Mill Street, turn left onto Main Street, and stop at the opera house in the center of Broad Brook. In less than a year, the Warehouse Point–to–Rockville line would also be open.

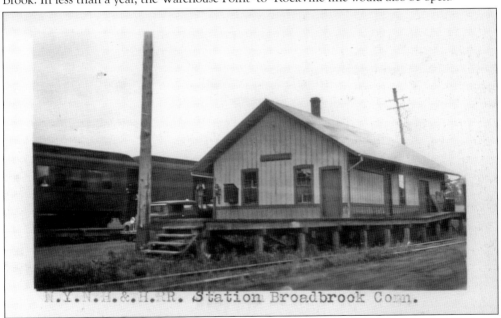

BROAD BROOK DEPOT, 1950s. In the 1870s, the New York, New Haven & Hartford Railroad laid tracks through Broad Brook and built a depot on what was then called New Street (Depot Street). Now the Broad Brook Mill and others could transport their goods by train instead of hauling goods by horse-drawn wagons to barges on the Connecticut River. The depot also served passengers and mail order deliveries. (Courtesy of Keith Cotton.)

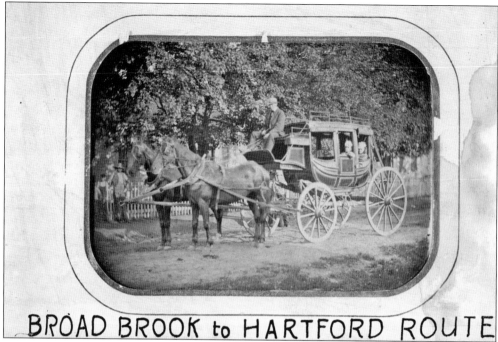

BROAD BROOK to HARTFORD ROUTE

LAST STAGECOACH, 1875. Stagecoach travel ended when the railroad came through. This coach ran the Broad Brook–to–Hartford route from the Broad Brook House (Fred Hambach, proprietor) at 27 Depot Street. Two other coach stops were the Tarbox Tavern in Scantic and the Reeves House in Windsorville. The inscription on the back of this photograph reads: "Last stagecoach driven in Connecticut, driven by Patrick Boyle of Wolcott Street, seated on driver's seat." (Courtesy of the Connecticut Historical Society.)

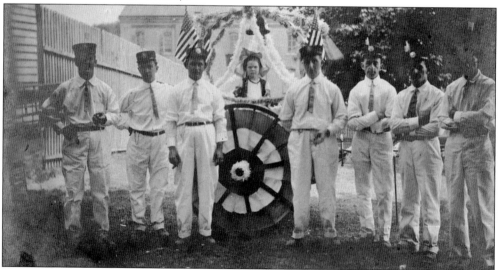

FIRST FIRE EQUIPMENT. To get the new fire department operational, the Broad Brook Company purchased a hand-drawn hose reel with 1,000 feet of hose, two standard Underwriter nozzles, two firefighter axes, one pry bar, and 12 leather buckets. In 1902, a hand-drawn chemical wagon was added to the inventory. Volunteer firefighters stand in front of the chemical wagon after a parade. Bernice Tyler is seated in the cart.

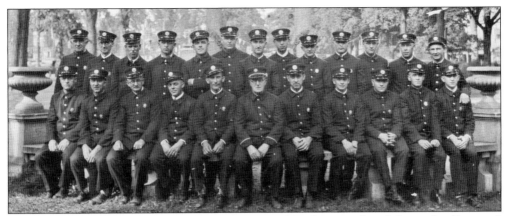

BROAD BROOK VOLUNTEER FIRE DEPARTMENT, 1925. Members are, from left to right, (first row) John Foster, Arthur Staiger, Herman Ungerwitter, Edwin Stolle, Richard Fiedler, Benjamin Hanson (chief), Laurence Loftus, Richard Thomas, Theodore Johndrow, Lenard Badstubner, and Herbert Staiger; (second row) Joseph Muska, ? Friedrick, Douglas Loftus, two unidentified, John Dorman, Francis Arzt, unidentified, Louis Ungerwitter, Herman Schlichting, Lester Foster, Mathew Pelton, and Barney Yanek.

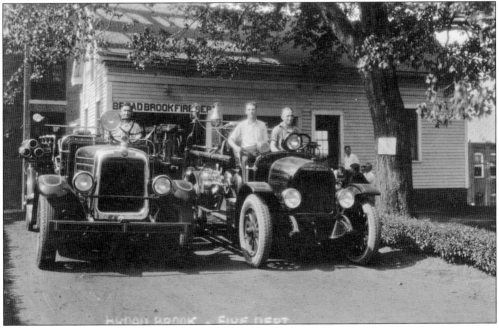

BROAD BROOK FIRE HOUSE, 1940. The Broad Brook Company established a fire department in 1896 and housed it in front of the mill across from the opera house. On the left, in a 1929 American LaFrance truck, sits Jack Artz. On the right, in a 1925 American LaFrance chemical truck, sit Albert Dremez (left) and Herbert Staiger. The department's first priority was to protect the mill and its holdings. (Courtesy of Warehouse Point Library.)

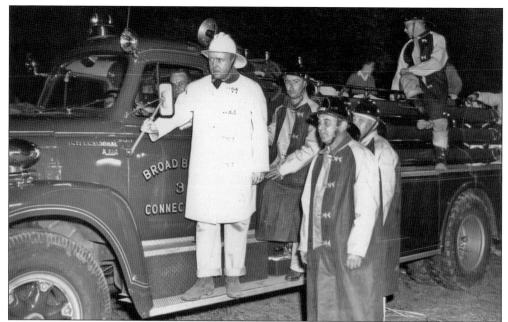

HOLLYWOOD ARRIVES. In 1960, Warner Bros. filmed a scene in the movie *Parrish* using the Broad Brook and Warehouse Point Fire Departments. A tobacco barn was set ablaze while cameras rolled. Carroll O'Connor played the fire chief and helped the departments extinguish the fire on the Daly property in Warehouse Point. From left to right are Fritz Badstubner, Carroll O'Connor, Jerry Hoffman, Bill Loos Sr., and Art Loos. The others are unidentified. (Courtesy of Broad Brook Fire Department and Robert Yosky.)

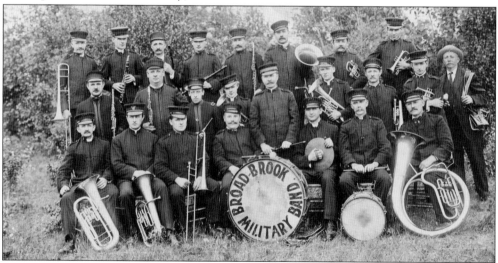

BROAD BROOK MILITARY BAND, 1910. Military bands provided martial music during official events, military funerals, parades, and concerts. Members are, from left to right, (first row) Fred Ungewitter, unidentified, Charles Etter, U. Merkel, Carl Ungewritter (standing), C. Staiger, Albert Goettler Sr., and Herman Schlichting; (second row) unidentified, P. Sullivan, Mike Ryan, Charles Ungewitter, Herman Ungewitter, Paul Kruger, unidentified, and Alfred Hahn; (third row) Otto Ungewritter, John Quist, unidentified, Albert Kruger, E. Lagel, Gus Schlichting, Oscar Badstubner, and Fred Badstubner. (Courtesy of Warehouse Point Library.)

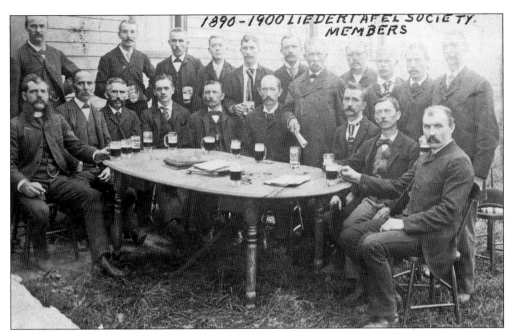

LIEDERTAFEL SINGING SOCIETY. The society was formed in the late 1800s by people who emigrated from Germany to preserve their customs and heritage. Two of the society's outstanding groups were the choral group and the brass band. When the organization was founded, only people of German origin could join. Today, it is a popular club at 75 Depot Street that sponsors activities, hall rentals, and a place for people to gather. Members of any nationality are accepted.

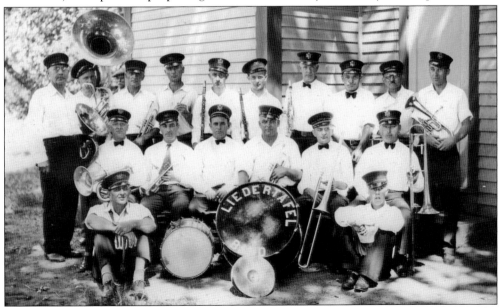

LIEDERTAFEL SOCIETY, 1935. Outside the German club, the band members are, from left to right, (first row) Kenneth Kreyssig and Fred Badstubner; (second row) Herman Ungerwitter, George King, Lewis Ungerwitter, and ? Fourner; (third row) Gustave Schlichting, Louis Shadlick, Lester Foster, Alfred Kreuger, John Shary, Edward Staiger, Bert Ellite, ? Loomis, Fred Ungerwitter, and Leonard Badstubner. Peeking around the corner is Herman Otto.

WELCOME HOME, WORLD WAR I. On September 27, 1919, a Welcome Home Day parade and celebration were held in Broad Brook for the returning servicemen and -women from Broad Brook, Melrose, and Windsorville. Veterans gathered in front of a very decorated opera house for a photograph. The Town of East Windsor presented a certificate of recognition to all its veterans.

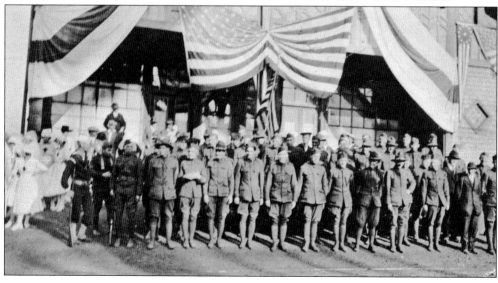

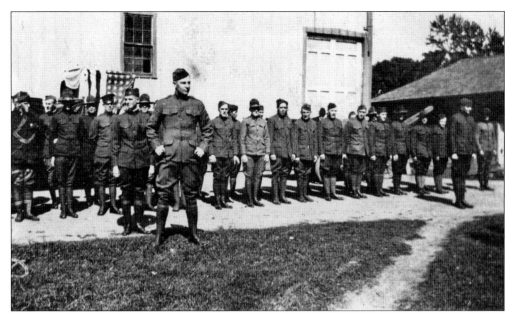

WORLD WAR I VETERANS. Getting ready to join in the Welcome Home Day parade, World War I veterans assemble in front of Sloan's Tobacco Warehouse at 68 Main Street. It was a very large parade, with floats, bands, and minstrels. Army tanks, a Gatling gun, and other types of armament were on display at the carnival grounds opposite the Mill Pond.

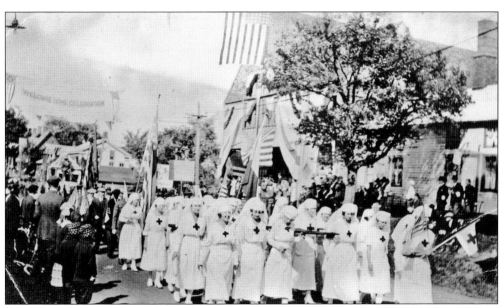

RED CROSS, WORLD WAR I. Area Red Cross workers march in the World War I Welcome Home Day parade. The American Red Cross played a vital role during the war. On the home front, it provided communication between troops and their families and financial aid to families who lost a serviceman. On the war front, it provided treatment for infections, wounds, mustard gas burns, exposure, and other types of severe war trauma.

WORLD WAR II OBSERVATION POST. In 1940, the federal government wanted a chain of observation posts established along the Atlantic and Pacific coasts. The object was to spot enemy aircraft and alert the nearest warning center, which then would contact a strategic fighter squadron. Citizens stood four-hour watches on a hill east of Warehouse Point off North Road. Spotters pictured here are, from left to right, Mae Grigely, Rosalie Chester, Emma Grigely, Josephine Montgomery, and Eleanor Pease.

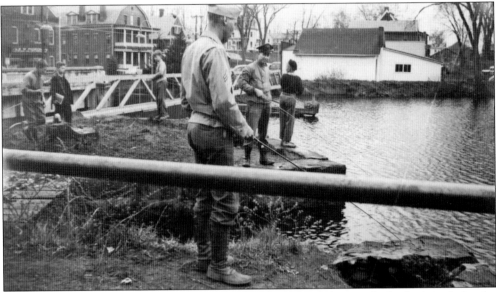

BROAD BROOK MILL POND. Mill Pond is part of the Broad Brook watershed, which includes the towns of East Windsor, Ellington, Somers, and Tolland. In the 1800s, the mill owners constructed two dams: one by the bridge on Main Street and another downriver. Besides these dams being useful sources of power, they also made the pond possible for recreation. Earl Hoffman (foreground) and Robert Norton are fishing while home on leave in 1943.

ARMY-NAVY PRODUCTION AWARD. The Broad Brook Company employees assemble in the opera house during the Army-Navy Award ceremony on February 12, 1943. The award signifies outstanding achievement in producing war equipment. Every employee of the Broad Brook Company received a pin to wear, and the company received a flag to fly under the American flag as a mark of contribution to the future of the country.

WELCOME HOME, WORLD WAR II. To honor the men and women who served in the armed forces during World War II, the second voting district of East Windsor, comprising Broad Brook, Melrose, and Windsorville, held a Welcome Home Day celebration on October 12, 1946. Assembled on the steps of the opera house for a group photograph are less than half of the veterans from the three villages.

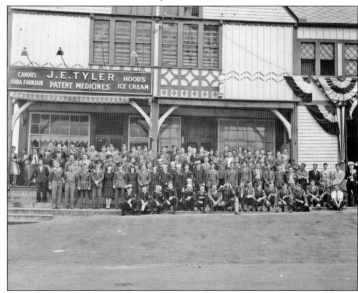

WELCOME HOME PARADE, WORLD WAR II. On October 12, 1946, participants gathered at Harrington's Corner, at the intersection of Main Street and Route 140. The parade included World War II and World War I veterans, their auxiliaries, military units from the Army air base at Bradley Field, societies from the three religious communities, brass bands and drum corps, schoolchildren, volunteer fire departments, and floats sponsored by local retail businesses. The parade marched down Main Street to the corner of Mill Street then marched back to the Broad Brook Hotel for a memorial service and presentation of medals. The speakers were Rev. Giles Goodenough, pastor of the Congregational church, and Rev. Joseph Rice, pastor of St. Catherine Church. Above is a gathering in front of Broad Brook Hotel, where the World War II Honor Roll was located. Below is the float "Homeward Bound," sponsored by the Broad Brook Company.

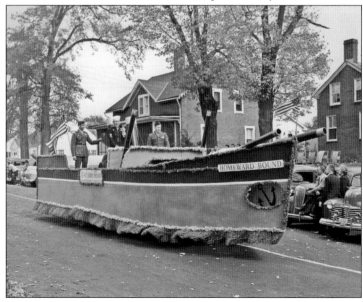

MEMORIAL DAY, 1947. A year after the Welcome Home Day celebration, citizens remembered their fallen with a parade. A three-volley rifle salute followed by the playing of taps was held at St. Catherine Cemetery in a somber ceremony. The practice of firing three volleys over the grave originated in an old custom of halting the fighting to remove the dead from the battlefield.

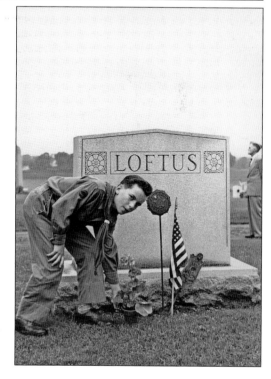

LOFTUS FAMILY MONUMENT. After the Memorial Day parade and ceremony in 1947, Samuel Loftus places a plant on the Loftus family monument in the St. Catherine Cemetery. Like many families at the time, several family members served their country. Carl Loftus, John Loftus, and Lawrence T. Loftus served in World War I. Lawrence J. Loftus served in World War II. The American Legion star grave marker signifies a veteran. The other marker is the Elm Progressive, an insignia of the Foresters of America fraternal organization.

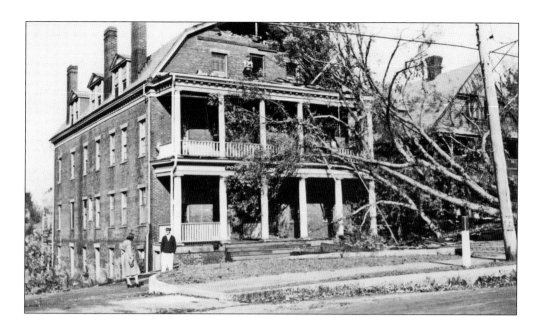

GREAT NEW ENGLAND HURRICANE OF 1938. One of the deadliest and most destructive tropical cyclones in two centuries hit New England in 1938. The storm formed near the coast of Africa on September 9 and became a Category 5 hurricane before making landfall on September 21. At the end of this six-hour storm, roofs were missing, porches were torn from houses, windows were broken, automobiles were crushed under fallen trees, and many buildings were torn from their foundations. The farming areas on the outskirts of the village fared no better. Tobacco sheds were blown down, and many caught fire with the tobacco inside. Many of these sheds were owned by small family farmers, and many farms did not survive this financial loss. Shown the day after is the Broad Brook Hotel, the A.H. Philips Grocery Store, and a destroyed tobacco barn. All were on Main Street.

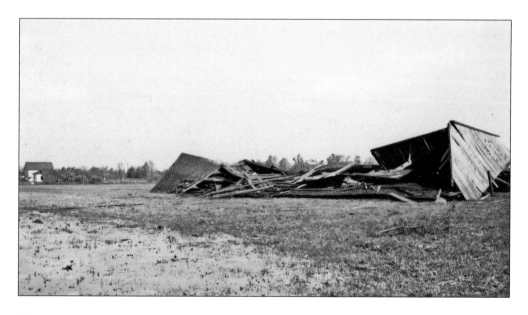

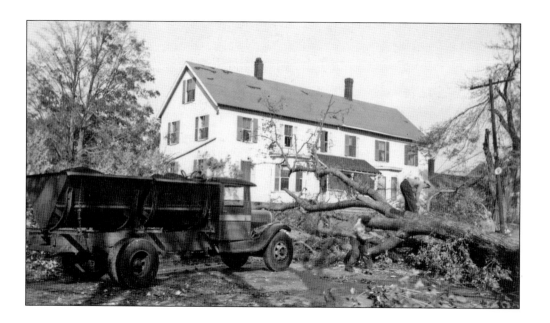

GREAT NEW ENGLAND HURRICANE OF 1938, CONTINUED. About 75 percent of the town's trees were blown down. After the hurricane, the government hired town men to remove the trees and other debris from the roads. All the clearing and cutting was done with hand saws and axes, as power saws and equipment were not yet developed. It took two weeks before the roads and bridges were temporarily repaired along with electrical power and telephone service. But it took six months before the utilities were operating at normal levels. Above is the home of Alec Cody and Roy Loomis at 82 Main Street, and below are the company houses on North Main Street.

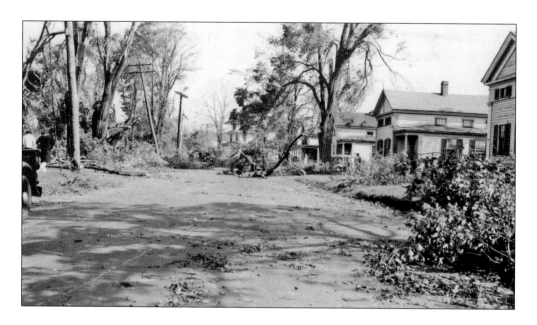

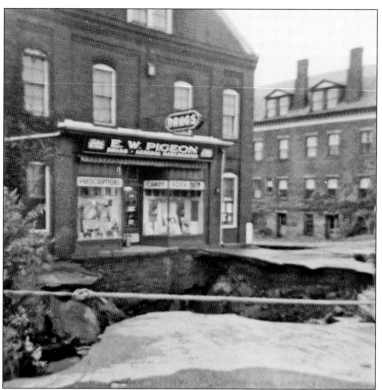

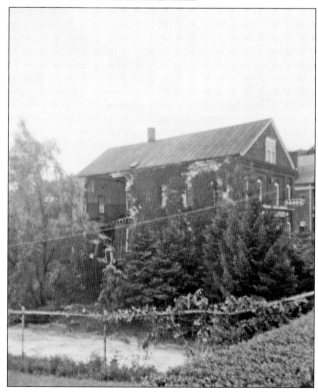

AUGUST 1955 FLOOD. The 1955 flood was the worst to hit Connecticut since 1936. Although two back-to-back hurricanes, Connie and Diane, did not directly hit Connecticut, they dumped a total of 17 to 26 inches of rain into the rivers, lakes, and ponds. Connie hit on August 11 and Diane on August 13. On August 18, a rain storm arrived, adding to the already saturated land. Mill Pond waters overflowed the dam, sending water rushing through the gorge so powerfully it undermined and destroyed the front parking lot of Pigeon's Drug Store and caused the rear side of the building to collapse. The center of the village was under several inches of water, not only from Mill Pond but also from Butternut Pond, Chestnut Brook, and the Scantic River. (Both, courtesy of Selma and Philip Grant.)

Four

THE VILLAGE OF MELROSE

Irish Row, now known by its post office and railroad name of Melrose, was first settled about 1730, when several Scot-Irish families with surnames including Thompson, McKnight, Harper, and Gowdy came from Northern Ireland with Rev. John McKinstry. Reverend McKinstry settled in Ellington, which would account for the fact that the Thompsons, Harpers, Gowdys, and McKnights went to the Ellington Congregational Church, while old settlers like the Allens and Peases went to the First Congregational Church in Scantic.

Melrose is nestled in the quiet northeast corner of East Windsor, bounded by the Scantic River on the west, Broad Brook on the south, and Ellington and Enfield on the east and north. Today it is a pleasant rural, pastoral area, but that was not the case when the farmers came. It was all forest, and they needed to clear the land for homesteads, livestock pastures, and crops. They used the wood as material for homes and barns and as a source of heat. Farming tools were mostly simple, hand-held iron devices like a scythe, a cultivator pulled by horses or oxen, a flail, and an ax.

Although hotels and stores were never established in this village, the business of farming was booming, along with a cider and vinegar mill and a large distillery. The village stayed close-knit by joining in social and farming activities. Families took part in the Four-Town Fair, bringing their steers and oxen to the cattle show and their sheep, swine, poultry, pets, agricultural and horticultural produce, and flowers for exhibition.

The first 4-H Club in Melrose was organized in 1927. Until that time, members were part of the Hampden County 4-H Club in Massachusetts. Melrose organized the first 4-H marching band in Connecticut in October 1959. Known as the Melrose 4-H Band under the direction of Louis Ungerwitter of Broad Brook, it won many honors for its musical and drilling ability.

Melrose began as a community of self-sufficient farmers, and evidence of this farming heritage is still visible today in its buildings and landscape. In recognition of this heritage, the area from the Capt. Samuel Stiles house to the Thompson-Pease Farm on Melrose Road is listed in the National Register of Historic Places as a historic district.

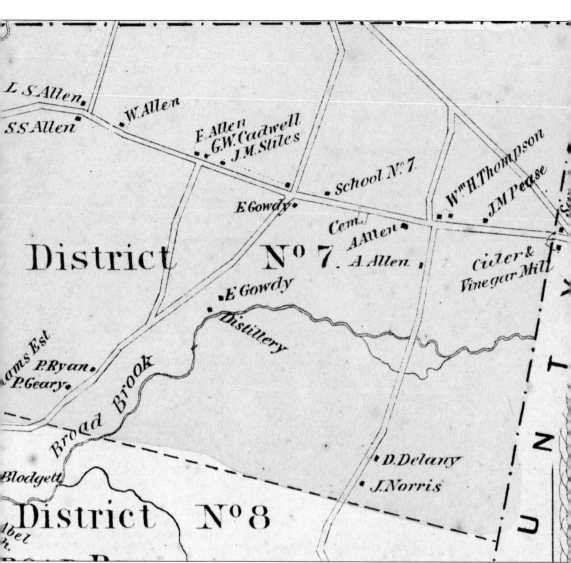

MELROSE MAP, 1869. At the time of this map, this area was known as Irish Row and was largely a farming community. The Allen, Stiles, Thompson, Pease, and Gowdy farms dominated the area along with the Gowdy Distillery. The post office and railroad were not in existence until 1876, when the village name became Melrose.

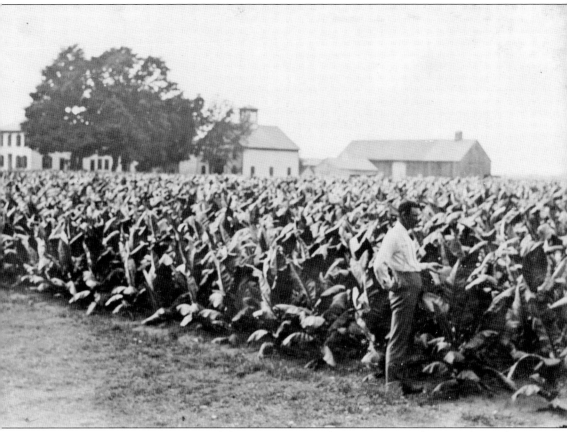

SELECTMAN, COWBOY, AUCTIONEER. Elisha M. Granger was born in East Windsor in 1856. At the age of 21, he went west to experience the cowboy life. There he learned the meat market business. Later, he spent three months helping drive 900 horses through Indian territory from Waco, Texas, to Kansas. He returned to East Windsor, and between 1880 and 1899, he married Susan Vining, raised two children, was elected as a town selectman and a state representative, and was marshal of the Four-Town Fair. Also during that time, he bought three Allen family farms in Melrose totaling 385 acres where he based his cattle business. One year, he had about 2,400 head. Here, at the corner of Grant and Melrose Roads, Albert H. Grant is inspecting his tobacco crop with the Granger farm in the background. (Courtesy of Albert and Stuart Grant.)

ELI GOWDY HOUSE. Positioned on the corner of Melrose and Broad Brook Roads, this homestead has remained in the same family since Robert Gowdy purchased the original 148 acres in 1825. The Gowdys and Grants have farmed at this site for over 190 years, making it a significant example of continuous farming. Robert's son Eli erected the house in 1830 with a combination of Colonial and Greek Revival features. A smokehouse and a meat storage room, complete with hooks, are still in the basement.

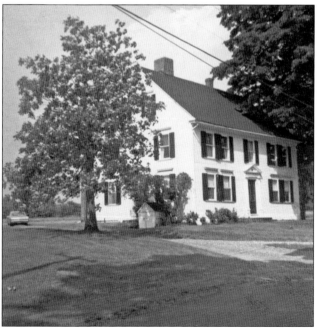

CAPT. SAMUEL STILES HOUSE. Captain Stiles was a devout parishioner of the First Congregational Church in Scantic and a prominent Freemason. A veteran of the Revolutionary War, he built this Colonial/Federal-style farmhouse at 169 Melrose Road in 1790. The captain died of consumption in 1813. The house served as the Melrose Post Office from 1937 until 1968. Emil Hambach was appointed postmaster in 1937, and Robert J. Hambach was appointed in 1949. (Courtesy of John Matthews.)

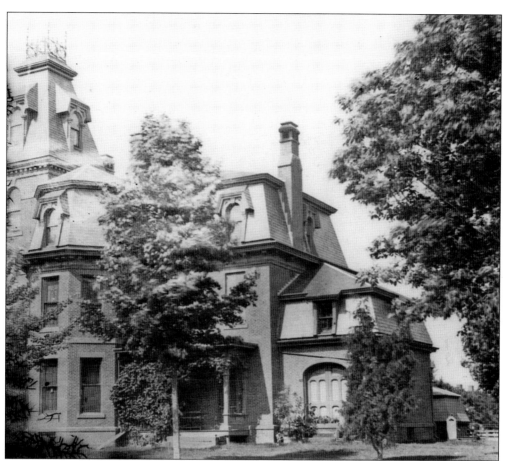

STILES MANSION. John Morton Stiles was a partner in the very profitable Gowdy Distillery along with his father-in-law and brother-in-law Eli and Francis Gowdy. After opening the distillery in 1861, he was able to build this elaborate mansion in 1875 on the northeast corner of Melrose and Broad Brook Roads. Its Second Empire style was popular in France at the time. Constructed of brick with mansard roofs, low, square-based domes, and side tower, it was unlike any other home in East Windsor. The tower served as an observatory for the family. Lost to a fire in 1934 along with its Victorian furniture, it was never rebuilt. The carriage house (right) remains as evidence of the mansion's existence but has been renovated to serve as a residence.

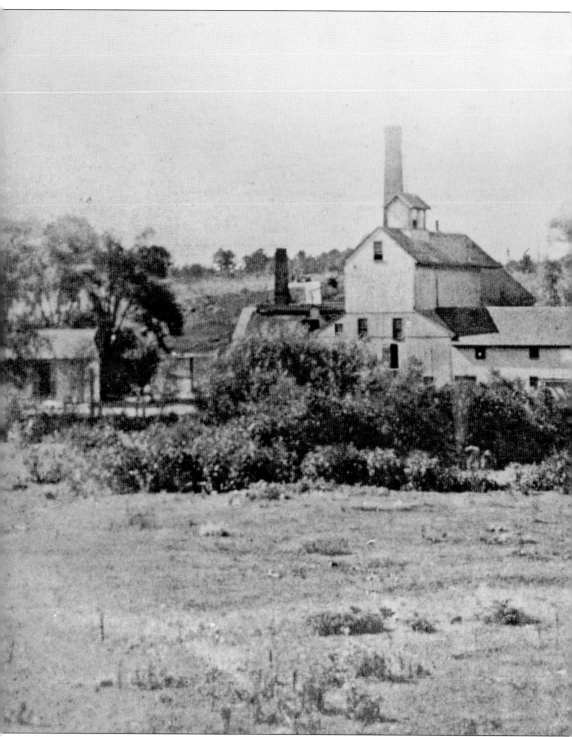

GOWDY DISTILLERY. In 1861, the Francis Gowdy Distilling Company, a large wholesale distillery, was south of Melrose Road and west of the railroad tracks. The distillery made gin for 44 years before closing in 1905. Its first run produced whiskey, and the second run produced gin. Since

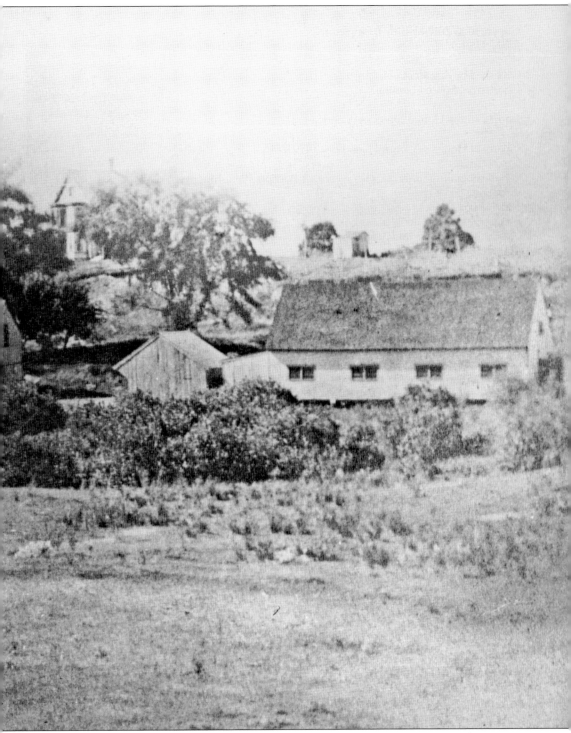
the juniper used to make gin coated the still, rendering it useless for other spirits, only gin was produced thereafter. (Courtesy of Selma and Philip Grant.)

DISTILLERY POND. The distillery needed water to power the machinery. To get this water, the Broad Brook Stream was dammed and a waterwheel installed. During the winter, ice was harvested and sold to companies and villagers. Here, two men are marking out the ice blocks with an ice plow in the early 1900s. (Courtesy of Selma and Philip Grant.)

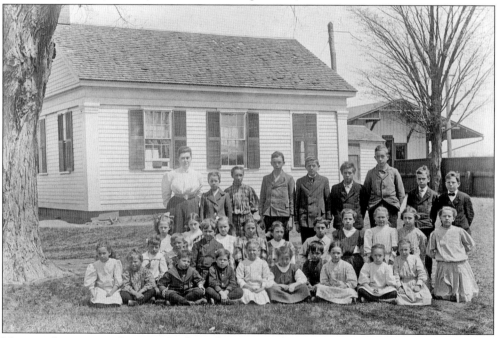

MELROSE SCHOOL AND LIBRARY. In the early 1800s, Melrose was District Seven of East Windsor's 12 school districts. Built in the 1850s, this one-room schoolhouse sat next to the Melrose Depot (the building on the far right). The library was established here in the 1930s. Due to damage from the 1938 hurricane, the school closed, but the library continued. It is now used for local functions. (Courtesy of Selma and Philip Grant.)

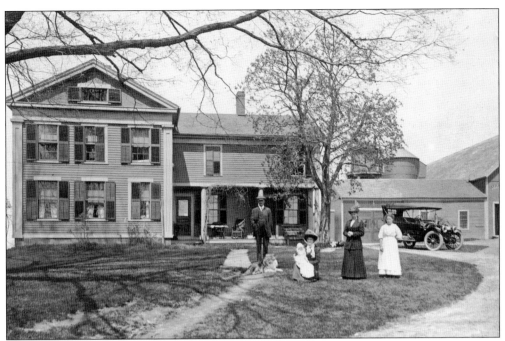

ALBERT H. GRANT HOUSE. This classic Greek Revival house was built about 1830 by Winthrop Allen. The farm sits on the northeast corner of Grant and Melrose Roads. Albert Grant purchased it from his grandmother's family, establishing a farm mainly growing tobacco. The Grant family also raised chickens, sheep, horses, and dairy cows. Shown in 1913 are, from left to right, Albert with the family dog, Dandy, Mabel Root with baby, Belle Roberts Grant, and maid Annie Kaminiskutie. (Courtesy of Albert and Stuart Grant.)

THE NEXT GENERATION. In the early years, farms were family-run, sustaining the family and hopefully providing an income through the sale of any surplus. Children reared on a farm grew up doing chores and working closely with the animals. The family farm passed from generation to generation, just like Albert Grant's farm in Melrose. Boyd Grant is holding his prize rooster in this 1910 photograph. (Courtesy of Albert and Stuart Grant.)

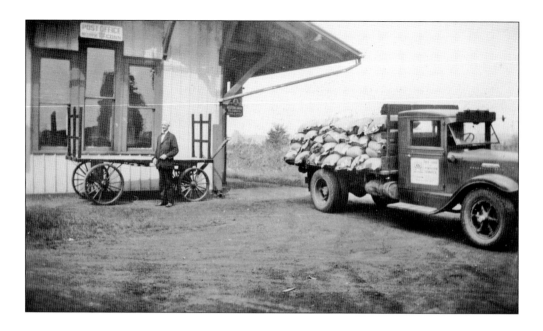

Melrose Depot. This stop was established in 1876 on the north side of Melrose Road next to the railroad tracks. After the first depot burned, it was replaced in 1897, and it was in use as a station until the late 1930s. The post office was housed here until 1937 with Richard J. Foley (standing in both photographs) as the postmaster and the railroad agent. The photograph above shows the Eastern States Cooperative railcars being unloaded onto L. Ellsworth Stoughton's International truck. The signage on the truck reads: "Feed, Seed and Fertilizer Service. L.E. Stoughton, Warehouse Point, Connecticut." The Eastern States Cooperative was comprised of the New England states, New York, and New Jersey, providing farmers with quality feed, seed, and fertilizer along with other items to help them be competitive. (Both, courtesy of Selma and Philip Grant.)

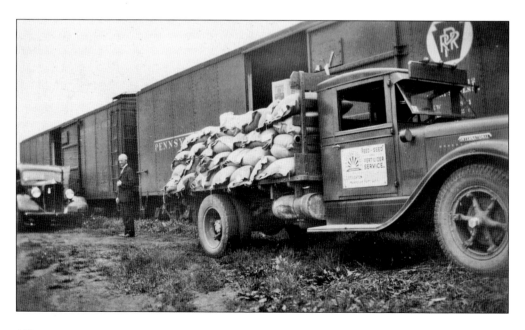

Trolley Trestle, Melrose, Conn.

TROLLEY TRESTLE. The New York, New Haven & Hartford Railroad tracks running through Melrose hindered a trolley line to Rockville. A 500-foot-long trestle, known as a "roller coaster" trestle, was installed to span the tracks, and on May 20, 1906, the Rockville line was open. Although the trestle was of lightweight construction, built by the Berlin Construction Company, the years proved it to be serviceable. To celebrate its opening, free one-way rides from Warehouse Point were provided by the trolley company, and Rockville merchants offered a free return ticket with a purchase above a certain amount. This line was abandoned in 1926. Note the train depot above and the Melrose schoolhouse below.

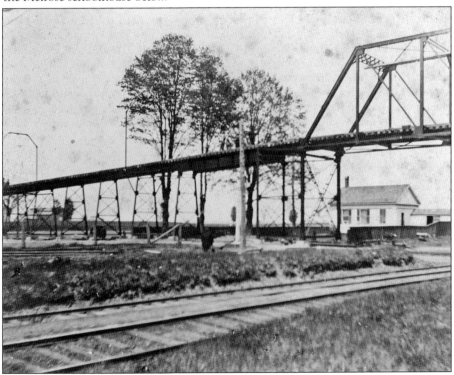

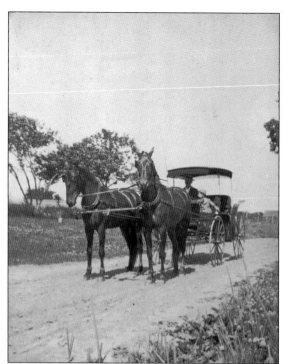

HORSE AND BUGGY. Albert H. Grant and his son Boyd are pulled by their horses Vic and Jasper around 1910. Buggies were the primary mode of short-distance personal transportation because they required only crudely graded roads. Until mass production of the automobile brought its price within the reach of the working class, horse-drawn conveyances were the most common means of local transportation.

GOAT CARTS. Unidentified children enjoy the diversion of a ride in a goat cart at the corner of Melrose and Broad Brook Roads. In the early 1900s, traveling photographers would use a goat cart as a mechanism to solicit business. It is unknown if this particular photograph is one of them. Since farming was a way of life in this area, the goat cart could have been owned by a family to haul farm products. (Courtesy of Selma and Philip Grant.)

Five

THE VILLAGE OF WINDSORVILLE

In the early 1700s, this section of East Windsor was called Ketch Mills because of the saw, woolen, and gristmills that utilized the power of Ketch Brook over the decades. Ketch Brook starts in Ellington and flows into the Windsorville Pond and then on to the Scantic River. The pond was formed by a dam built to sustain the mills. The first mill was a sawmill built in 1687 by Samuel Grant Sr. and Nathaniel Bissell. Later, Timothy Ellsworth, son of Lt. Solomon Ellsworth of Scantic, ran a grain grinding mill and gin distillery. His business was the chief source of growth and prosperity for the neighborhood at the time, with his gin distillery operating for 50-plus years before it burned in 1842. During the cider season, Ellsworth also produced cider and cider brandy. Two years after the fire, P.C. Allen opened a woolen mill in its place. The woolen mill operated for another 50-plus years before it too was destroyed by fire.

Ketch Mills had many entrepreneurs and was once its own community with mills, a church, a post office, and stores. William Robertson kept a tavern; Mr. McFalls a blacksmith shop; Captain Cahoon the first hotel; Timothy Ellsworth and Thomas Potwine a retail store; and Sumner Sheppard a store and post office on the edge of the pond. Mulnite Farms, on Graham Road, was established in 1905 and operated until 2016.

In the 1880s, the US Fish and Fisheries Commission was concerned with the declining population of food fish and shipped carp for stocking waters. Caleb Leavitt participated in this experiment and stocked the Windsorville Pond.

In 1827, the Ketch Brook Post Office was opened, and in 1849, its name was changed by the US Post Office to Windsorville. In 1877, a train depot was built on Apothecaries Hall Road to accommodate the growing village. The arrival of electricity eliminated the need for water-powered mills, thus bringing about the end of the village's heyday.

Windsorville today is a small community to the south of Broad Brook that has kept its rural beauty and charm.

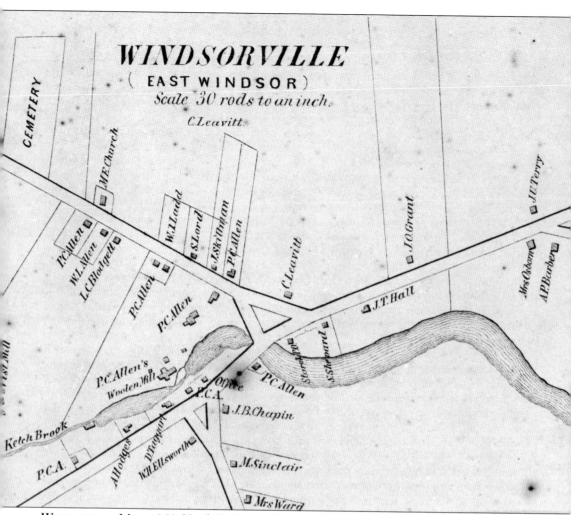

WINDSORVILLE MAP, 1869. Until 1849, the village was known as Ketch Mills. At the time of this map, businesses located along Ketch Brook are (from lower left) L.C. Blodgett's Factory and Grist Mill, P.C. Allen's Woolen Mill (formerly Timothy Ellsworth's grain grinding mill and distillery), and, just after the bridge, S. Shepard's Store and Post Office. Windsorville Methodist Church (upper left) had been moved to the village by this time.

CENTER OF VILLAGE, 1900S. This scene presents a view of the center of Windsorville in the early 1900s. Looking north from the corner of Rockville and Windsorville Roads, the Ford Model T has just traveled over the bridge on this unpaved road. No telephone poles are erected as yet, and most homes have fences to keep animals from wandering into the road.

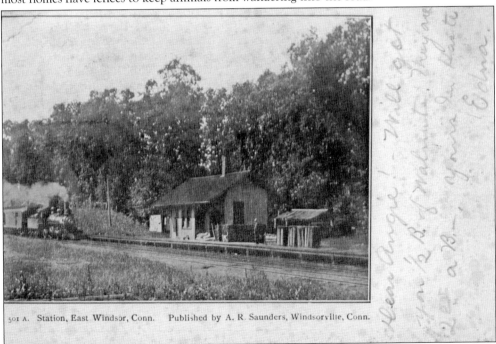

501 A. Station, East Windsor, Conn. Published by A. R. Saunders, Windsorville, Conn.

OSBORN STATION, 1911. This little-known train depot and telegraph station sat on the west side of the tracks on Apothecaries Hall Road. Built about 1877, it served the Windsorville area, especially the woolen mill on Ketch Brook in the center of the village. It was a flag station, which meant the train would only stop if someone flagged it down.

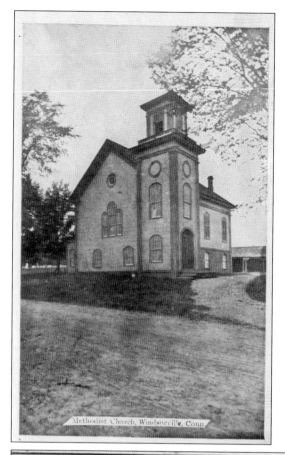

Methodist Church, Windsorville, Conn.

WINDSORVILLE METHODIST CHURCH, 1910. In 1829, the area Methodist society built a meetinghouse by the old District 11 schoolhouse near the corner of Thrall and Clark Roads. In 1858, it voted to relocate the church to the center of the village. Property on Windsorville Road was purchased, but not all parishioners were happy with the move, and they had an injunction served on the movers. Private hearings were held at the state capital, and the injunction was dismissed. Finally, the church was moved by oxen over several days. Services resumed in 1858. The church was lost to a fire in 1876 but rebuilt in a much grander style drawn by H.H. Treat. The corner tower is Greek Revival, and the round-arched windows are Italianate style. (Both, courtesy of Keith Cotton.)

Interior of M. E. Church, Windsorville, Conn.

A. R. Saunders, Publisher.

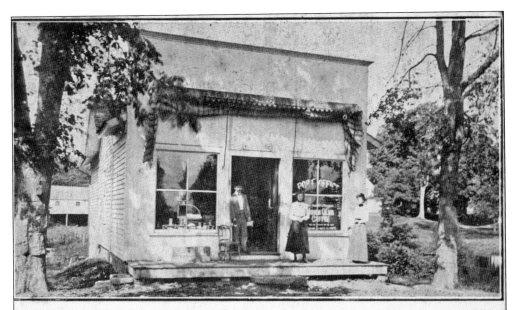

Store and Post Office, Windsorville, Conn.　　　　　　　　　　A. R. Saunders, Publisher.

S. Shepard Store and Post Office, 1910. The Ketch Mills Post Office, established 1825, was, in the early years, located in a general store at the corner of Windsorville and Thrall Roads. It stood just north of the bridge on the edge of the pond. The postal name changed to Windsorville about 1849, changing the name of the village. In the 1840s, Sumner Shepard operated the store, and he was postmaster until his death. In the 1950s, the post office was moved to its final location at 188 Windsorville Road. It was in continuous use until 1983, when it was closed and integrated into the Broad Brook Post Office. (Both, courtesy of Keith Cotton.)

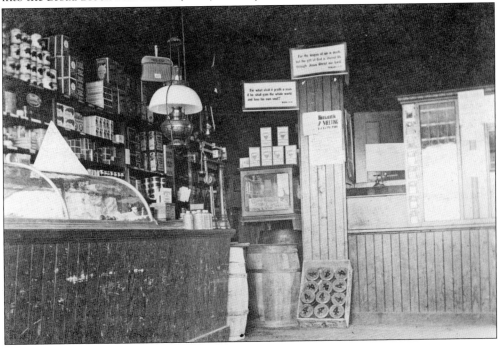

The "Bums" Camp. It is unclear when hobos first appeared at railroad tracks. After the Civil War, many returnees started hopping freight trains to get home and others to find work. During the Great Depression, the number increased considerably. One camp was located approximately 200 yards into the valley of Ketch Brook, near the Osborn railroad station on Apothecaries Hall Road. Here Francis Kreyssig, a town resident, visits the site with his family in 1934.

Windsorville General Store. The Warehouse Point Drum Corps leads this 1947 Memorial Day parade in Windsorville. Note the Red & White Food Store and Mobil gas station that operated in front of Ketch Brook on the west side of Windsorville Road. Red & White stores were independently owned grocery stores in small towns. The company centralized buying and distribution, which enabled small stores to compete with the larger chains.

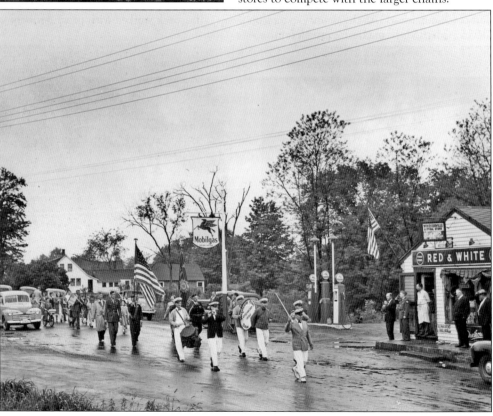

Six

OUR AGRARIAN ROOTS

All the villages of East Windsor came into being because of farming. The Connecticut River valley, which includes East Windsor, has some of the most fertile and productive land in the United States. In 1680, Simon Wolcott crossed the river from Windsor and established the first farm in the soon-to-be town. Others followed to settle their families and work the land raising crops like corn, hay, potatoes, and rye. They raised livestock, including beef and dairy cattle, oxen, horses, hogs, sheep, and poultry. Family farms eventually started selling their surplus. Even people who were not full-time farmers did some farming; the local blacksmith or miller would have a cow or a horse and a patch of land to raise vegetables.

Before the Revolution, tobacco had become an important crop in the valley, with East Windsor playing a dominant role. Native Americans were already growing tobacco in the 1600s when the first settlers came, and by the 1700s, tobacco was king. Prominent East Windsor families like the Bissells, Ellsworths, Wolcotts, Grants, Talcotts, and others were growing tobacco widely. Within a decade, it became a major crop, with some farmers exporting it to the West Indies.

In the early years, tobacco was mainly for pipe use. When the popularity of cigars grew greater than pipes, broadleaf tobacco was the variety that dominated the scene. The use of East Windsor's broadleaf as a cigar wrapper leaf began with imported seeds from Virginia. Area farmers grew tobacco for the two outside layers of cigars, the binder and the wrapper. In the 1900s, when the Sumatra leaf, grown in Cuba and Sumatra, exceeded the quality of the valley's cigar wrappers, shade tobacco came into existence. Growers found they could match the Sumatran leaf by making shade tents of cloth to cut sunlight and raise humidity. Connecticut shade tobacco was born.

Today, the farms are still alive and well, as evidenced in the resurgence of local farmer's markets, confirming that the town's heritage is firmly planted in its agricultural past.

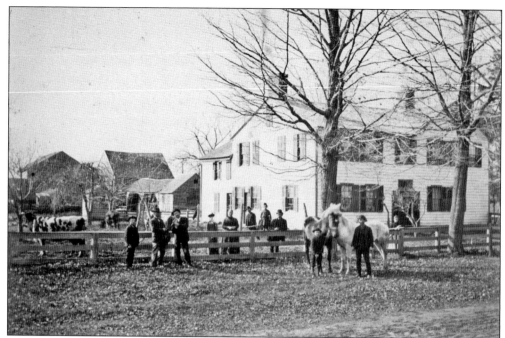

O'NEILL FARM, 1800s. Shown is the classic working family farm of James O'Neill in Scantic. O'Neill married Bridget Cleary, also of East Windsor, and they raised nine children. According to the town tax records of 1886, the farm consisted of one home, 44 acres of land, two horses, and six cattle. The family is shown by the fence, cows are in the apple orchard, and numerous outbuildings are in the back. (Courtesy of the Connecticut Historical Society.)

DOMESTIC OXEN. Before the horse collar was invented, farmers made use of oxen teams to farm their land. Oxen were used for plowing, transporting, pulling carts, hauling wagons, and even riding. Frank Osborne is standing next to his powerful team of yoked oxen, hauling logs in the early 1900s on Town Street (now South Main Street), Warehouse Point.

ICE HARVESTING. In the early 1900s, long before refrigerators, ice was harvested from frozen lakes and ponds. Large blocks were cut and loaded onto horse-drawn sleds to be stored in ice houses and delivered to households with ice boxes. Here, townspeople are harvesting the ice from the Windsorville Pond. (Courtesy of Keith Cotton.)

EAST WINDSOR'S PASTURELANDS. This is a pleasant winter scene in East Windsor. Although residences and businesses have been added to the landscape over the years, because of the town's agrarian roots, scenes like this one can still be found in all five villages.

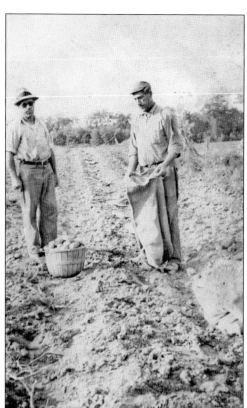

HARVESTING POTATOES. Potatoes grow in full sun, moderate temperatures, and light, rich, acidic, well-drained soil. With East Windsor's prime land, farmers grew bushels of this root crop. Early settlers would sell or store them in root cellars to sustain their family through the winter. Pictured are Sam Goss (left) and Oscar Hunt harvesting potatoes at the Wells Farm in Scantic in the 1920s. (Courtesy of Michael Hunt.)

GROWING FIELD CORN, 1933. The early settlers found the Native Americans cultivating an unknown crop—corn. No European had eaten cornbread, corncakes, or even corn on the cob. The corn fields in East Windsor fed families and livestock and supplied the gristmills and distilleries in the region. Looking west, this corn field, with the family farm in the background, was located on the corner of Old Ellington and Norton Roads in Broad Brook.

DAIRY FARMS. Grazing in a grass pasture is part of the herd of milk cows owned by George Grant. Most of the herd were milking shorthorns. The Meadowpark Farm consisted of 178 acres in the Melrose section of town. (Courtesy of Selma and Philip Grant.)

SILAGE. Silage is fermented, high-moisture, stored fodder that can be fed to cattle, sheep, and other livestock. Silage must be firmly packed while being stored to minimize the oxygen content or it will spoil. Philip Grant of Park Farm is unloading hay crop silage to be fed to the dairy cows in 1955. (Courtesy of Selma and Philip Grant.)

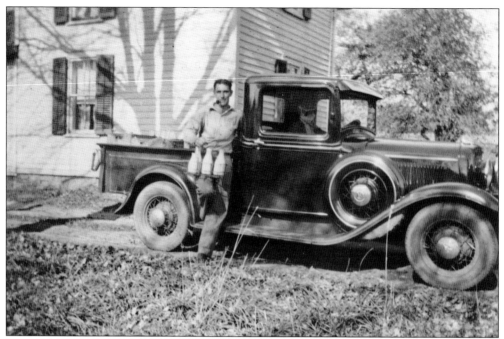

MILK DELIVERY. During the 1900s, the Pease farm in Melrose was a large dairy farm that also grew corn and other crops. In the 1930s, home delivery of milk and bread was commonplace. Ed Pease is delivering milk to the villagers in the iconic glass bottles with the cream on top.

SHEEP FARMING. Maple Shade Farm in Melrose, owned by the Grant family, was typical of the cottage industries of its day. The family produced goods for their use and also for sale. The farm raised sheep, chickens, horses, and dairy. The farm name came from the maple trees that lined the street at that time. (Courtesy of Albert and Stuart Grant.)

SOWING TOBACCO SEED. All tobacco is raised from seed and planted in early April. The seeds are extremely small, not much larger than a pin prick. It is very easy to seed an area too thickly. George M. Grant of Melrose is sowing seed in a sterilized bed in 1908. The trolley trestle is in the background. (Courtesy of Warehouse Point Library.)

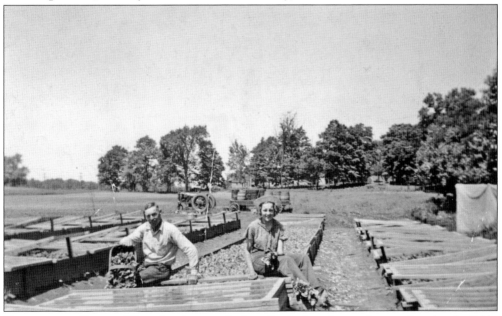

TRANSFERRING PLANTS. When the plants reach about five inches, they can be transferred to the fields. In May 1938, Michael Yosky and his daughter, Albina Yosky Kalmer, are removing the young plants from the bed to plant in the fields at his Broad Brook farm. (Courtesy of Patricia Donahue.)

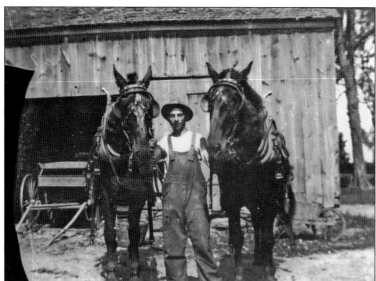

HORSE POWER. In 1908, George M. Grant of Melrose was one of the largest tobacco growers in East Windsor. Clyde Grant is getting ready to hitch draft horses to the tobacco setting machine. (Courtesy of Selma and Philip Grant.)

TOBACCO SETTING MACHINE. A setting machine is drawn either by a tractor or horses digging a straight trench to the depth required for the plants. Water barrels on the machine deposit water where each seedling is to be placed. The men, holding trays of seedlings on their laps, set the plants in the dirt. The machine then covers the roots and pushes soil around the stalks. Clyde Grant is driving, with Fred August (left) and Fred Kreyssig sowing a shade field in Melrose. (Courtesy of Warehouse Point Library.)

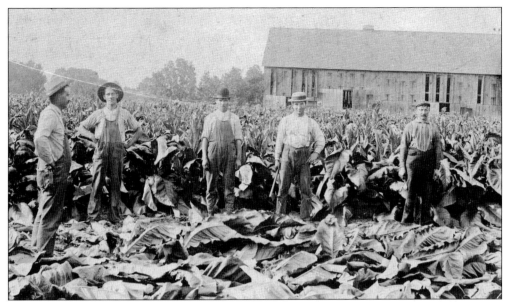

CUTTING THE CROP. To harvest broadleaf, the stock is cut at ground level with a hatchet and laid on the ground to wilt. From left to right, Lemuel Stoughton, L. Ellsworth Stoughton, Jim Yuskavish, Peter Zikovich, and Tony Tamashitis are working on the west side of Route 5 in Warehouse Point at John Stoughton's farm in 1916.

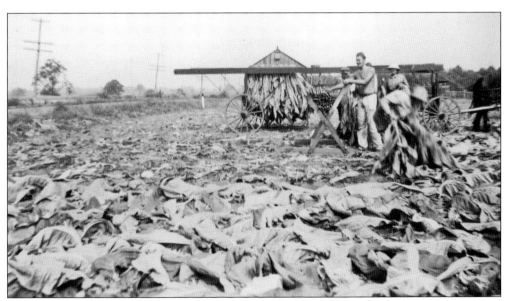

HARVESTING BROADLEAF. Now that the plants are cut and wilted, Constantine Titus and Pauline Putriment spear the plants onto a tobacco lath, a wooden lath with a spear on the top. The lath is driven into the ground and each stalk is pierced onto it. Each lath generally holds five to six plants. This farm was on Scantic Road in Scantic in 1937. (Courtesy of Warehouse Point Library.)

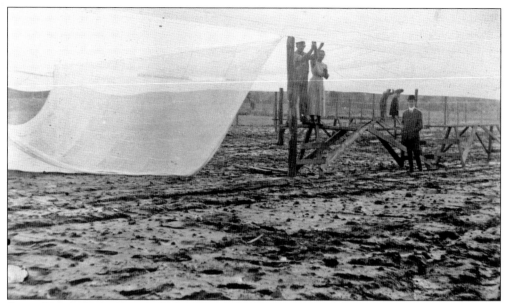

SHADE TENTS. To compete with the Sumatra leaf being raised in subtropical regions like Sumatra and Cuba, growers used cotton cloth to shade the tobacco while growing. Posts were set in a grid layout, wires were strung from post to post, and a light, durable cloth (cotton at first) was stretched and draped on the wires. With the sunlight diffused and the humidity and temperature under the cloths higher, a more elastic tobacco leaf that cures to a lighter, even color similar to the Cuban and Dominican cigar is produced. (Courtesy of Warehouse Point Library.)

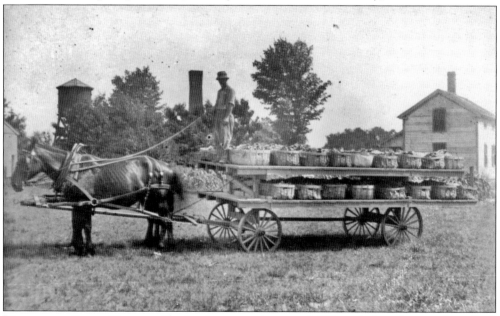

HARVESTING SHADE TOBACCO. Shade tobacco was harvested differently from the open broadleaf. Instead of the whole plant being cut down, only the leaves were removed. Workers would go row by row and remove only the ripe leaves, placing them in baskets to be transported to the sheds to be hung. Fred August is hauling baskets of leaves in 1908 at the Grant farm in Melrose. (Courtesy of Warehouse Point Library.)

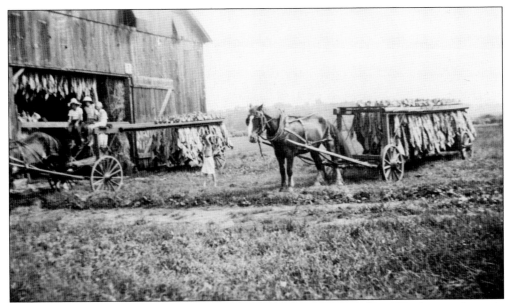

Barns. Tobacco barns were scattered by the hundreds throughout East Windsor in the early 1900s. Since then, many have rotted and fallen, been blown over by hurricanes, or burned down due to fires during the curing process, lightning strikes, or vandalism. Here, broadleaf tobacco is waiting to be hung so it can be dried. This barn was located at the corner of Stoughton Road and Route 5 in 1937. (Courtesy of Warehouse Point Library.)

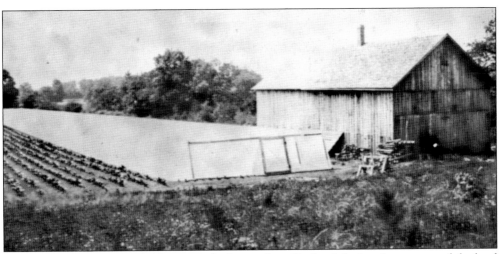

Tobacco Fields. Tobacco fields growing both open broadleaf and shade tobacco covered the land all over the five villages of East Windsor. Both types are shown here next to a typical tobacco barn. (Courtesy of Warehouse Point Library.)

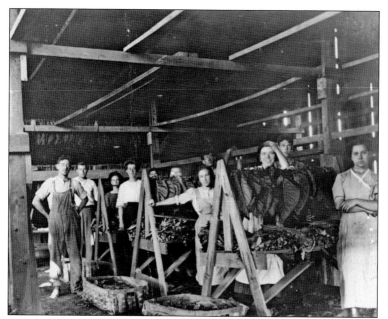

HANGING SHADE TOBACCO. Before the leaves could be hung to dry, they needed to be attached to a wooden lath. Workers would attach leaves to pin-laths and hang them from beams to dry. Another method was to sew the leaves with a needle and string to the laths before hanging. This shed was owned by George Grant in Melrose in 1908. (Courtesy of Warehouse Point Library.)

MAKING CHARCOAL. After tobacco is harvested, it needs to be fire-cured. Tobacco is hung in large barns where fires of hardwoods are kept on continuous low smolder, and it can take up to 10 weeks to cure. Fire-curing produces a low-sugar and high-nicotine product. In the 1900s, farmers made charcoal by stacking hardwood and burning it down. These days, updated forms of fire-curing are used. Another method is air-curing.

SLOAN'S WAREHOUSE. Tobacco was a very important industry throughout the Connecticut River valley, and Sloan's tobacco sorting warehouse was one of five that existed in the town. Pictured above is Elbert Sloan's tobacco warehouse, which was destroyed by fire in 1946. It was attached to a tobacco barn that was full of dried tobacco. When the barn caught fire, the barn, warehouse, and crop went up in smoke. Shown below are, from left to right, Elbert H. Sloan, two unidentified tobacco crop buyers, and Hilard Sloan in 1938. To make it easier to spot his warehouse, Elbert put his name in slate on the roof of the building he owned at 66 Main Street. It can still be seen today: "E.H. SLOAN."

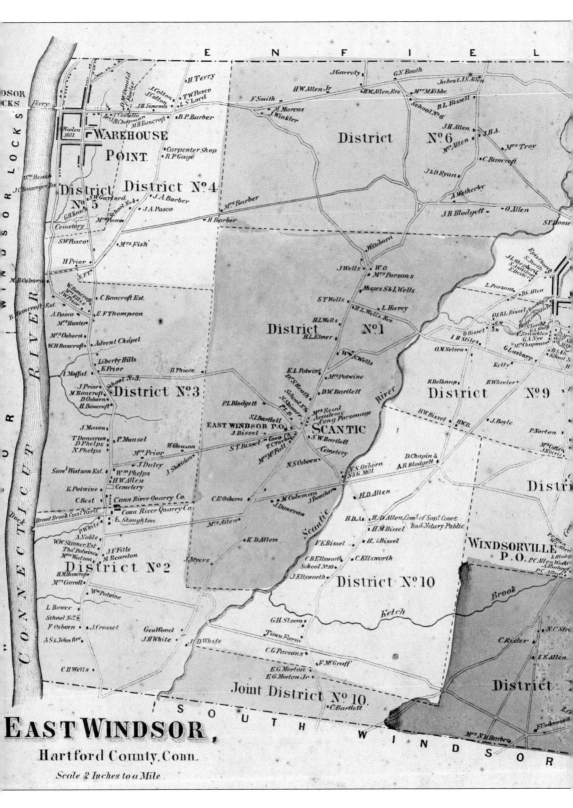

ENFIELD

WINDSOR LOCKS

WINDSOR LOCKS

Ferry

Woolen Mill

WAREHOUSE POINT

Carpenter Shop
R.P.Gage

District No. 4

District No. 5

District No. 6

District No. 1

District No. 3

District No. 9

District No. 2

SCANTIC

EAST WINDSOR P.O.

District No. 10

WINDSORVILLE P.O.

District

Joint District No. 10

SOUTH WINDSOR

CONNECTICUT RIVER

EAST WINDSOR,

Hartford County, Conn.

Scale 2 Inches to a Mile.

124

EAST WINDSOR MAP, 1869. East Windsor was incorporated on May 17, 1768. This map shows the five villages with landowner and business locations 100 years later. At that time, there were 12 school districts, and each district was required to establish a school.

BIBLIOGRAPHY

DeVito, Michael C. *East Windsor, Through the Years*. Warehouse Point, CT: The East Windsor Historical Society Inc., 1968.

————. *Transportation Bulletin No. 80. Hartford & Springfield Street Railway Co*. Warehouse Point, CT: National Railway Historical Society. January-December 1973.

First Congregational Church. *The One Hundred and Seventy-fifth Anniversary*. Thompsonville, CT: Press of H.C. Brainard, 1927.

Potwine, G. Stephen. *East Windsor Heritage: Two Hundred Years of Church and Community History, 1752–1952*. East Windsor, CT: First Congregational Church, 1952.

Stiles, Henry R. *History and Genealogies of Ancient Windsor, Connecticut*. Hartford, CT: Press of the Case, Lockwood, and Brainard Company, 1892.

Stoughton, L. Ellsworth. *Notable Memorabilia, First Congregational Church*. East Windsor, CT: East Windsor High School Graphic Arts, 1984 revision.

Stoughton, Lemuel. *East Windsor During the 1800s*. Unpublished manuscript. Scantic, CT: 1897. East Windsor Historical Society, East Windsor, CT.

Taylor, William Harrison. *Taylor's Legislative History and Souvenir of Connecticut Volume VI, 1907–1908*. Putnam, CT: 1908.

Town of East Windsor Bicentennial Program, 1968.

Vozek, Joseph. *The Village of Broad Brook Vol I and II*. Broad Brook, CT: Self-published, 1994.

Wells, S. Terry. Unpublished diary, 1890. Connecticut Historical Society, Hartford, CT.

ABOUT THE ORGANIZATION

The East Windsor Historical Society was organized in 1965 in anticipation of the 1968 bicentennial of the incorporation of East Windsor, Connecticut, due primarily to the efforts of the founding president L. Ellsworth Stoughton. Its purposes are to discover, procure, and preserve whatever may relate to the civil, ecclesiastical, and natural history of the town of East Windsor in particular and the state of Connecticut in general. Its aim is also to collect, preserve, and publish historical and biographical material relating to East Windsor and its five villages: Warehouse Point, Scantic, Broad Brook, Melrose, and Windsorville.

The grounds of the museum encompass five buildings. The original Scantic Academy, built in 1817, houses the society's collection and is listed in the National Register of Historic Places. The Ertel/Geissler Barber Shop, built in 1892 and relocated from Broad Brook, and the Probate Court, relocated from Warehouse Point, display original items. The Farm Tool Museum, built in 1975 from part of an 1831 tobacco shed owned by Stephen Potwine, contains large farm equipment and a carriage used for many years by the local Smith Market. The newest building is a restored two-story Colonial house built by Samuel Osborne in 1785.

Membership is open to everyone, and visitors are welcome at 115 Scantic Road, East Windsor, Connecticut. Admission is free. The society is always looking for volunteers. Visit the website at www.eastwindsorhistory.wordpress.com or the Facebook East Windsor Historical Society page for more information and for visiting hours.

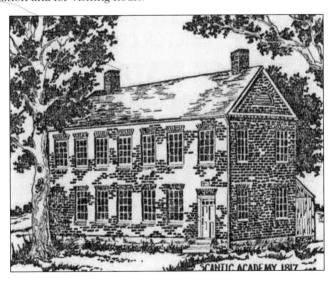

SCANTIC ACADEMY 1817

DISCOVER THOUSANDS OF LOCAL HISTORY BOOKS
FEATURING MILLIONS OF VINTAGE IMAGES

Arcadia Publishing, the leading local history publisher in the United States, is committed to making history accessible and meaningful through publishing books that celebrate and preserve the heritage of America's people and places.

Find more books like this at
www.arcadiapublishing.com

Search for your hometown history, your old stomping grounds, and even your favorite sports team.

Consistent with our mission to preserve history on a local level, this book was printed in South Carolina on American-made paper and manufactured entirely in the United States. Products carrying the accredited Forest Stewardship Council (FSC) label are printed on 100 percent FSC-certified paper.